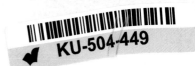

The Photographic
Studios of Europe

H Baden Pritchard

MUSEUMSETC | EDINBURGH & BOSTON

CONTENTS

STUDIOS IN SCOTLAND

STUDIOS IN FRANCE

Publisher's note

This book uses the text of the original 1882 edition of H Baden Pritchard's classic work, *The Photographic Studios of Europe*. This new edition has been redesigned, newly typeset and edited to make it accessible for contemporary readers. Those wishing to explore more deeply will find a reproduction of the full Victorian edition, with period typesetting, additional studio descriptions and more detailed technical and chemical information freely available online.[1]

1 http://archive.org/details/photographicstu00pritgoog

Introduction

The practical worker is very seldom a writer. He not only lacks time and opportunity to record his experiences, but generally underrates their value, and does not think them worth, recording. This fact comes home very forcibly to those connected with photographic journalism, and to it is due the contents of this volume. Having found again and again the practice of photographers so different to the teachings of textbooks and periodicals, we resolved upon a house-to-house visitation among the principal studios of Europe, determined to write down great things and small alike, as they came under our observation, and so produce a record of practice. At first, we feared that friends on whom we called might possibly resent our visit, and for this reason we made it a rule to intimate straightway that "if you have anything you desire to keep secret, do not mention it, and it will not get into print." But we may say at once that the caution was never taken seriously, and we did not once fail to get a straightforward answer to any of our questions.

Our object in compiling this book has been two-fold: to produce a readable volume, and at the same time to afford practical information. We are well aware that our work is incomplete.

The alternative was before us of postponing the publication of this volume until the series of representative studios was more perfect, or publishing forthwith such information as we had gathered together during the past two years. We decided upon the latter course, for the reason that our writings already fill one goodly volume, and that some little time may elapse before we have an opportunity of visiting Russia and Southern Italy, where several studios of note are to be found. In our next edition of the *Studios of Europe* we hope to include a description of these and several others; but as it is, we do not think our readers will complain of lack of enterprise. Where a studio of special interest was to be found, we have permitted no difficulties to stand in the way of seeing it. Whether the establishment was within the span of a London cab-drive, or beyond the reach of railways, we have visited it, if it were worth visiting, and the fact that a distance of something like fifteen hundred miles lies between Messrs. Valentine's studio at Dundee, and that of Herr Koller in Perth, is proof sufficient that our information was not obtained without some labour and fatigue.

We have pointed out that it was with a view to watch photographers at work that we undertook

these practical essays; but we are in hope the professional photographer will be able to make use of our volume, beyond learning of the formulas and manipulations of successful men. The arrangements of the reception-room – the rules and regulations in vogue with sitters – the prices charged for portraits – the sending out of proofs, and matters that concern the business of the photographer generally, have received particular attention, and we cannot but think that many will derive useful hints from the information thus brought together. As to the construction of the studio and darkroom, we have noted points from which many cannot fail to profit, and those engaged in building a new studio, or in re-arranging an old one, should derive benefit from our notes on the subject. The good work of the photographers we speak of in these pages will be known to our readers, and, no doubt, the latter will be able to perceive in our account, now and again, certain indications as to the manner in which this good work is obtained. All must, perforce, learn something; everyone who reads of an improvement on his own mode of working will be gratified, no less than those who, cognisant already of what these pages tell them, will be confirmed in the proud knowledge that there

is nothing other photographers can teach them.

Without further preface, we set down the contents of our volume.

Nile, wandered over Palestine to Jer
s of the Holy Land. The young
f, and the life and soul of the p
ce asked Mr. Bedford to remain l
ographs, and insisted on our friend
d of fifty soldiers to keep him and hi
ries of 210 plates were secured by M
of these 175 were subsequently selec
ce good-naturedly permitting Mr. B
e pleased with them. But perhaps
. terms on which prince and phot
ded some years afterwards at Pall M
es, busy inspecting the pictures on th
d and said, "But where is Mr. Bed
ord." That gentleman, however, wa
the cordial manner in which Mr. B
 showed that His Highness still r
sures of the tour they made in compa
e bright landscape pictures of Mr. :
ot less talented son, Mr. William B
lation in these columns. In the san
ars to enjoy a sort of monopoly i
he Messrs. Bedford stand pre-emin
 landscapes and craggy headlands
is a trough a dozen feet long, in w
res of English scenery are washi

Francis Bedford
at Camden Road

Twenty years ago, shortly after the death of the Prince Consort, his Royal Highness the Prince of Wales started on a journey to the Holy Land. The tour had been projected by Prince Albert, who traced it out with much care and forethought, the spots to be visited being such as he desired to impress particularly upon his son's mind as being likely to educate and interest the future King of England; and after her husband's death, her Majesty did not hesitate to carry out the project. The party selected to accompany the Prince was small, but well chosen. It included General Bruce, who was to be a sort of commander-in-chief of the party, Colonel Teesdale, Colonel Keppell, the Hon. Robert Meade, a college friend of the Prince, a physician in the person of Dr. Minter, and Dr. Stanley, the late Dean of Westminster. As this modern crusade was on the eve of starting, there came a hasty command from Osborne decreeing a further addition to the party; Mr. Francis Bedford was sent for by the Queen, and, after a few preliminaries, was introduced to the Prince of Wales as an extra travelling companion

It is pleasant, even after this lapse of time, to listen to Mr. Bedford's reminiscences of this right Royal tour. They journeyed straight to the

Mediterranean, where HMS Osborne was waiting to convey them into the Levant; they boated on the Nile, wandered over Palestine to Jerusalem, and visited the relics of the Holy Land. The young Prince was affability itself, and the life and soul of the party. At Hebron, the Prince asked Mr. Bedford to remain behind to take certain photographs, and insisted on our friend being provided with a guard of fifty soldiers to keep him and his apparatus from harm. A series of 210 plates were secured by Mr. Bedford on his tour, and of these 175 were subsequently selected for publication, the Prince good-naturedly permitting Mr. Bedford to do pretty well as he pleased with them. But perhaps the best proof of the good terms on which prince and photographer travelled was afforded some years afterwards at Pall Mall, when the Prince of Wales, busy inspecting the pictures on the wall, suddenly turned round and said, "But where is Mr. Bedford? I don't see Mr. Bedford." That gentleman, however, was at the Prince's elbow, and the cordial manner in which Mr. Bedford was received at once showed that His Highness still remembered vividly the pleasures of the tour they made in company.

The bright landscape pictures of Mr. Francis Bedford, and of his not less talented son,

Mr. William Bedford, require no commendation in these columns. In the same way as Mr. England appears to enjoy a sort of monopoly in Continental pictures, so the Messrs. Bedford stand pre-eminent in reproducing the soft landscapes and craggy headlands of our own country. Here is a trough a dozen feet long, in which many hundreds of pictures of English scenery are washing, the moving water bringing them into view one after another. The prints are small, none larger than whole plate size, and many of them for the stereoscope; but they are all alike in this: they are sharp and vivid, but so soft and delicate, withal, that they look like exquisite engravings. "There is Exeter Cathedral," we say, "and that is the Valley of Rocks, and that is Lynmouth, with its big rocks and wave-beaten wall; what a charming coast picture!" The last photograph is a favourite with Mr. Bedford, for it can never be taken again; they have improved the place and carried away those big frowning rocks by the causeway, he tells us.

As a large publisher of pictures, Mr. Francis Bedford has paid great attention to the question of permanency in silver prints. He will have nothing to do with paper sensitized out of England, and he is particularly careful to wash well. This

is his plan: after toning and fixing, the prints are thrown into water, and an assistant, agitating them one by one by hand to free them as much as possible from the hyposulphite, passes them into a series of troughs. Into the first of this series of troughs falls a fast running stream of water, which overflows into the second trough, and from this into the third, and so on. The assistant washes his prints up the stream, which may be likened to that in the fable of *The Wolf and The Lamb*, progressing from one trough to another until the prints arrive at the source. They are now taken out and put into the large washing trough, where they remain for something like eighteen hours. The trough has a false bottom of lattice-work, on which the prints rest – if they may be said to rest at all – and under this lattice-work is a serpentine tube through which, in winter time, passes hot water, so that the washing is kept at a tepid temperature. Like Mr. England, Mr. Bedford employs a little water-wheel, but he applies its motive power differently. When this water-wheel revolves, which it does about once a minute, from its buckets becoming filled, it naturally makes a revolution, and, so doing, turns a crank; this crank causes a sort of flapper to work to and fro in the water, which is

thus vigorously stirred, and agitates the prints. Moreover, there is a long arm or lever in the water, to the end of which is attached a float; so long as there is plenty of water the float swims and the lever does not act; but should the extreme end of the lever sink for lack of water, the other end rises and at once checks the water-wheel, when the supply of water flows into the trough uninterruptedly until the float (at the end of the lever) rises again.

Next in importance to his washing arrangements, the plan adopted by Mr. Bedford to collect residues calls for notice, Not less than 75% of the silver expended in printing is got back again at Mr. Bedford's establishment, a fact we would impress upon our readers with particular earnestness. Economy is frequently pushed to the extreme in studios in the matter of purchases, while the saving of residues is deemed a matter of secondary importance. From his hyposulphite solutions, Mr. Bedford estimates that he recovers half as much silver as from the first washing waters, a circumstance, we are sure, that will cause surprise to many photographers. The plan adopted to recover the washing of prints in exceedingly simple, effective, and very easily explained. The three first wash-waters are supposed to contain

all the silver salt that is worth collecting, and these are poured down a sink in one corner of the apartment; in the next room is a rubber tube connected with this sink, and here, too, are three big earthenware pans, each of them of sixty-gallon capacity, embedded in sawdust for protection against frost and injury. The rubber tube permits these pans to be filled one after another. When No. 1 is full, hydrochloric acid is added, and the liquid permitted to stand; No. 2 is next filled, and in its turn No. 3. By this time the chloride of silver in No. 1 has been precipitated; the clear liquid is drawn off, and the pan, which is pivoted at the bottom, may be relieved of its precipitate, or refilled with washings by means of the tube. The precipitate is filtered through flannel, dried, and then sent to the refiners; the converting of the mass again into nitrate is wisely left to the manufacturing chemist.

In the sensitizing room of Mr. Bedford's establishment – which, by the way, is exceedingly compact and complete – are facilities for exciting and drying 120 sheets of paper at a time. Four huge baths of nitrate of silver are ranged in a row on a low dresser, and by the time an assistant has floated a sheet on the fourth, the first is ready to lift up and put over the drying rod. A long trough upon

wheels is placed under the wet sheets to receive the droppings of the precious liquid, the trough being moved along as every fresh row of sheets is added.

Most of the printing is conducted under glass, a linen screen being pulled across overhead if the sun begins to shine, for the sashes above are otherwise found to leave their mark on the delicate pictures. Every negative is edged with black paint, for the double purpose of giving the prints a white margin – especially agreeable in the case of un-mounted prints, and Mr. Bedford issues all in this condition – and to economise the toning bath. The deep black edges in an ordinary print, Mr. Bedford avows, run away with as much gold as the picture itself. Finally, the painting of the margin facilitates the marking of the negative with its number.

The cracking of the negative film is rarely seen now, and this is attributed by our host to the circumstance that the collodion is bet-ter than it used to be. It is the latter, and not the varnish, that is at fault. Mr. Bedford has had negatives closely packed together, and almost unused, which on unpacking have shown de-fects of this nature, while others freely stacked In boxes have exhibited nothing of the kind.

An ingenious method of improving the skies

in negatives and softening the horizon line, and perhaps adding detail to a foreground, is adopted by Mr. Bedford. His former plan, as many of our readers know, was to cover certain portions of the negative with tracing-paper, and work with pencil, stump, or brush upon this. Tracing-paper, however, gets yellow and opaque in time, and in any case shows a very decided outline. But by grinding the reverse face of the negative – Mr. Bedford, like a careful photographer, always employs patent plate – by means of a glass muller and emery powder, a surface is secured upon which work of any description can be done. A few free strokes with a brush dipped in Indian ink, or with a pencil, add frequently to the value of a negative, while the mere grinding of the glass behind the horizon line, whether sea or ridge of hills, tends to soften this portion of the plate considerably. In a word, there are very few photographers who take such extreme cere over their printing as the Messrs. Bedford.

Mr. William Bedford has recently devised an instantaneous lens mount, which he describes as a hall and socket exposing valve. He says: "I give a diagram, where, in order to make the arrangement more clear, the ball-and-socket are represented in perspective inserted in a cross section of the

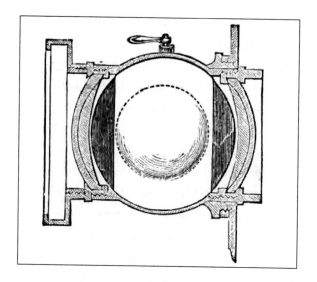

lens. Although I have not yet practically worked out this design, the one I have made is very similar to it, and almost identical with the stopcock arrangement of Mr. Bolas, the only difference being that Mr. Bolas prefers to place his between the lens and the sensitive plate, whereas mine acts between the lenses of a double combination. In this latter position the ball-and-socket principle would possess the advantage of occupying less space, as the lenses can be brought nearer to a ball than to a cylinder of the same diameter, so that a larger working aperture of the lens is available.

In the diagram, the dotted circle marks

the position of the apertures in the tin metal ball when the light is turned off. These apertures do not act as a stop, but allow the image to fall on the plate, in much the same manner as a shutter sliding near the plate does.

Of course there are optical as well as mechanical difficulties to be surmounted before any such principle would be practicable; but when we remember what was effected in the case of Johnson's Phantascopic camera, may we not hope to have a somewhat analogous principle successfully applied to such an important branch of the art as instantaneous photography?"

Payne Jennings
at West Dulwich

Apart from Mr. Payne Jennings' rare skill and refinement in the art of making pictures – qualities that few of us can ever aspire to –there is much in his work that may be studied with advantage by every photographer. He has shown in the true spirit of an artist how all-powerful is the pencil of light. He coquettes with pebbly brook and leafy dell, wooing nature under every humour. Now he follows the coy maid into green vale and over purple moorland, now under shadow of deep boulders beside the rushing foam, now among the yellow-green willows of a placid backwater he makes his capture. Sunshine or shade; the bright lakelet or gloomy cavern; the shadowy foliage of lofty tree, or tender undergrowth of fern and flowret; the black-lichened rock, or snow-flecked clematis – all are tenderly limned upon the sensitive plate, and the sweet pictures thus crystallized for ever.

Mr. Payne Jennings, then, is one of that small band – we might almost count the number on our fingers – who can gather pictures by the wayside with his camera. His pictures – and one can only say this of a very few workers – are published and purchased as pictures, and not as photographs of this spot or that. But as an art-photographer he has done more than this. "Delicacy and brilliancy I

believe to be perfection in a photograph," said our host; "and to secure these a light tone appears to me absolutely indispensable." It is to this decided opinion that we owe the new school of printing, for we can hardly call it by any other name, with which Mr. Payne Jennings has made us familiar. Warm tints and delicate tones are no novelty, it is true; but when we have a photographer coming forward who dares to risk the printing of all his work in one particular tint and depth, we must acknowledge that he has courage to back his belief in spite of every prejudice, while the success that has attended Mr. Payne Jennings' publications is ample proof of the correctness of his views.

At Dulwich there is but a printing establishment, and nothing more. Mr. Jennings rarely mounts his own pictures; all his efforts, when not very busy with the camera, are confined to printing; and since he has to supply during the present season some 90,000 impressions for Christmas cards, it may be taken for granted that this work is quite enough to occupy his attention. We all know that Christmas Annuals are written in the summer time, and that the stories of snow-bound travellers that are served up to us every year in coloured bindings in which the holly berry and

robin redbreasts prevail, are usually thought out and elaborated in the dog days; but even with this foreknowledge it strikes one as strange to see photographic printers busy in the hot months upon work that is destined for midwinter sale. Yet here, at Dulwich, in the piping hot sunshine, they are printing away at photographs for Christmas at the rate of a thousand a day. Heaps of prints lie before us, all of that delicate warm tone which Mr. Payne Jennings loves; they are little vignetted landscapes, carte size, in sheets of six, and, as we look on, an assistant is hard at work with a pad of felt on the table before her, and a short wooden knife in one hand, smoothing and flattening them, sheet by sheet. Deftly she seizes a curled and cockled print, and puts it, face downwards, on the pad; then, passing the wooden knife edge over the back, working from the centre, she converts the sheet into smooth paper, and gives it a "set", so that the impressions may be piled without difficulty.

What are Mr. Payne Jennings' rules as regards printing, it will be asked. In the first place, he employs a strong sensitizing bath – or, at any rate, not a weak one – never under fifty grains to the ounce; he invariably sensitizes, prints, tones, and fixes in one and the same day, performing the operations

as quickly one after the other as he can. He has recourse to acetate toning, and, as everybody knows, he does not carry the toning too far. He believes that the hyposulphite bath always requires to be neutralized with carbonate of ammonia, and he never employs anything but glazed earthenware in which to wash his prints, since it is not likely to harbour hyposulphite. During the first hour that the prints remain in the washing trough (into which fresh water is continually running), and after they have passed through several preliminary rinsings, they are continually being manipulated by hand, each sheet being turned over and separated, so that they may be perfectly washed.

The paper is very quickly sensitized and dried; ten minutes will usually suffice for the operation. This is the sensitizing room, and very light and airy it is. The front is of glass, covered with one thickness of yellow tammy; but an additional screen is provided to protect the sensitized paper, and to keep in the warm air, just by the fire. A sheet is floated, drawn as usual over a rod at the end of the bath, and then lifted against the edge, so that it draws with a sucking action, bringing up with it the minimum of solution. The sheet is then blotted against filtering paper, to still further

remove the liquid, and is then so slightly damp that in five minutes all superfluous moisture has been driven off. The surface is now rubbed with a soft rag to remove any fibre from the filter-paper, and it is ready for the printing-frame. Many might call the paper still moist, but, at any rate, it is not dry enough to cockle. The pressure-frames are set in the shade, and, as all Mr. Jennings' negatives are very thin, the printing goes on apace. Mr. Jennings' paper has a faint roseate hue.

With few exceptions, Mr. Payne Jennings prints from reproduced negatives. Indeed, he could only print so many pictures in this way. The original negative is treated as they do the original dies at the Royal Mint; the sovereigns that are coined in large numbers every day are all from the same original engraving; but it is from replicas of this, and not from Mr. Wyon's own handiwork, that the actual striking takes place. Mr. Payne Jennings follows this example. From the original negative a transparency is produced by means of carbon tissue, which, as our readers know, the Autotype Company prepare especially for such purposes. This transparency is usually dense enough without any intensifying; but when it comes to printing a negative from it (also in carbon tissue),

reinforcing, to some extent, is necessary. This is done by means of permanganate of potash, the tissue, be it stated, being developed invariably upon thin patent plate coated with a film of gelatine. In this way Mr. Jennings has no difficulty in producing negatives – which are never dense – all of the same intensity, so that he can print half-a-dozen of them at a time in one frame.

Besides the small work, and his large, well-known studies, Mr. Payne Jennings is at this moment engaged in illustrating no less than eighteen different volumes of poems – "all, I am sorry to say, in silver," said Mr. Jennings. "I should much like to employ a mechanical process, or carbon, or platinotype, and I hope sincerely I may soon be able to do so; my only desire is to produce prints as delicately and brilliantly as I can, and, so far as I have seen, none of these processes can compete with silver. I shall be only too happy to adopt them when results as beautiful are to be secured by their means." Mr. Payne Jennings, as a producer of pictures, must please his master – the public; this is the main point he must keep steadfastly in view.

Mr. Payne Jennings, for his camera work, prefers either spring or autumn. Spring in half-leaf is the best time, he thinks; the graceful outline of

the trees is seen to advantage, and the wind has less power than upon full foliage. Many photographs, he thinks, are marred by accidental lights; you want broad effects, and not lighting here, there, and everywhere. Again, photographs against the light furnish finer contrasts than can he obtained in any other manner; masses of shadow thrown into relief are then secured, and the lighting is much bolder. Mr. Jennings does not think that extra-rapid plates, however useful they may be, will add to the number of our artists; the art-photographer rarely wants to work with an exposure of one five-hundredth of a second. He does not care much about depicting express trains going at lightning speed, or four-horse coaches at twelve miles an hour. He is concerned more in obtaining a bit of romance or poetry in his sketches – in depicting a deep-shadowed glen or a sedgy pool in which the yellow water-lilies grow. An old water-mill beside the flowing river, forsaken, and in ruins, that lies here on the table, seems certainly to bear out what our host says. It embodies the well-known German ballad of the *Mill-Wheel*:

In einem kühlen Grunde
Da geht ein Mühlenrad,

Mein Liebchen ist verschwunden
Die dort gewohnet hat.

"I, for one," says Mr. Payne Jennings, "do not believe in any formula giving a weak sensitizing bath. The paper dealers, I know, frequently send out printed instructions, which you are asked implicitly to follow, and give you a silver bath as low as 30 grains to the ounce. I have, however, never been able to work this successfully, and generally find 50 grains to be the minimum strength compatible with good results. In the sensitizing dish it will be well to have a glass rod attached to one end, and each sheet of paper should be pulled over this after sensitizing; it may then be blotted off on stout blotting-paper, and hung up to dry. I think it is much better not to have the paper bone dry when placed in the frames, especially in summertime. Before placing the paper on the negative it should be carefully wiped with a piece of clean linen or silk, as the fluff from the blotting-paper adheres slightly to the surface. There can be no doubt that shade-printing in all cases is the most economical (except, of course, in the very exceptional case of a hard negative), there being much less likelihood of your amassing a large quantity

of defective prints. The general depth of your batch of prints must depend entirely upon the state in which you keep your sensitizing and toning bath. The intelligent printer knows well that it is here he must give his best attention, if he desires uniformity in his daily results. Let the printing bath be always of uniform strength, and the due proportion of acetate of soda and gold in the toning bath, and you will rarely, if ever, get into trouble. You know at once what reduction will take place in your print, just as though you saw it finished and dry before you; but let irregularity creep into the formula, and your day's work will certainly be more or less a failure. The rules regulating the sensitizing and toning baths must be rigidly observed, and to carelessness in this respect may be attributed the majority of printing failures, and general want of uniformity in results. To keep the silver bath in workable strength, a stock-solution of silver – 80 grains to the ounce of water – should be kept in readiness to the hand of the sensitizer, and 1 ounce of this solution added to every five sheets sensitized, care being taken to agitate the dish, so as to equalize the strength of the solution.

"*Toning:* For toning the print, I believe the ordinary acetate bath is the best, giving, as it

does, such beautiful warm tones, and which I myself am partial to. When the prints are taken from the printing-frame, they should be well washed in three or four changes of water, and, lastly, in water containing a handful of salt.

Toning Bath

Chloride of gold	1 gram
Acetate of soda	35 grains
Carbonate of soda	5 grains
Water	8 ounces

A convenient form of stock solution to add to the toning bath (as it loses energy) is as follows:

Chloride of gold	15 grains
Acetate of soda	2 drachms
Water	1 ounce

A portion of the solution, regulated by the daily average of sheets of paper toned, should be added to the bath after the day's toning is done; it will then be in good condition for the next use. It will, however, always be found wise to have two or three baths in use, and work them alternately.

"The prints when taken from the toning bath should be again placed in water containing

a little salt, and afterwards well and carefully washed in several changes of water.

"*Fixing*: For fixing, I believe a strong hyposulphite bath is the best, not less than 4 ounces to the pint of water, care being taken to neutralize with carbonate of soda or ammonia. For washing, the best plan, in my opinion, is to wash a comparatively short time, and have a boy constantly turning the prints over during that period; first turning them all face up, and then going through the whole batch again, and turning them in a contrary direction, and so on."

Walter Woodbury
at South Norwood

If we divide the history of photography into two periods, that which preceded collodion upon glass, and that which has followed it, we shall find in the second era no name more prominent than that of Mr. Walter Woodbury. Woodburytype, to the modem photographer, is as "familiar in his mouth as household words," and is, and apparently will be, for many years to come, the only photo-engraving process of practical and commercial value. What a fortunate idea to light upon, many have thought in becoming acquainted with Woodburytype for the first time, and how lucky Mr. Woodbury was to have conceived it! Few consider the matter seriously, nor dream that there have been tedious experimenting and elaborate labours preceding the work.

Mr. Woodbury appears to have never been without a camera since he was old enough to carry one. Articled to a civil engineer, he had barely served his time, than he went off to Australia, when thirty years ago the popular tide set in that direction. Like Moses with the green spectacles, he forthwith purchased a camera with his available cash – about the most useless thing he could possibly buy, without chemicals and other necessaries for the taking of photographs. However, the latter were afterwards acquired, when Mr.

Woodbury had suffered some of those vicissitudes which the bard tells us "acquaint a man with strange bed-fellows." Indeed, so successful was he with his camera, when once firmly on his feet, that in 1854 the prize medal was awarded to him for photography in the Australian Colonies.

Quitting Australia, we find Mr. Woodbury in 1857 and 1858 in Java, taking pictures for the Sultan, and to prove how weft these were executed, we have but to refer the reader to the charming transparencies of scenery in the Tropics, published in 1859 by Negretti and Zambra. We were looking at a series the other day of these glass stereoscopic slides, the photographs printed upon albumen, and we fearlessly assert that nothing of the kind which has been produced in recent years excels the delightful pictures of luxuriant foliage and eastern vegetation which Mr. Woodbury produced nearly a quarter of a century ago.

What is this curious little picture Mr. Woodbury brings to us ? It is in a tiny frame, and represents a table decked with fruit and flowers, coloured vases, and gilded ornaments. It is a photograph, and yet it is resplendent in colours. Mr. Woodbury laughingly strips off the backing, and then we find it is a Woodbury

transparency on glass, with a roughly-coloured ground beneath. It was made in 1868, and represents one of the earliest examples of this kind of work – a photographic image over a coloured groundwork – which, from that day to this, has been brought before the public under one name and the other. The French patented process, of which we have heard so much lately, about *photographies impressionées par la lumière* is, of course, simply one example the more of this old dodge.

But we must come to the present day. Mr. Woodbury has plenty to show us, and here at Manor House he has laboratory and workshops full of interesting matters. This oblong little box standing on end, about fourteen inches high, and six inches broad, is Mr. Woodbury's balloon apparatus. It is not difficult to explain. It is carried into the air by a small balloon, which is tethered to the ground by an electric wire. It hangs down from the balloon exactly in the position in which we see it standing upright on the table. The lens is uncapped at will by a revolving disc, which revolves once every time the operator sends an electric current from below. He sees when the balloon has done gyrating, and between the turns makes his exposure. He can make four exposures at every ascent of the

balloon, for he has four plates. These four plates are fixed to four faces of a cube, and this cube also makes one quarter turn (bringing another face, or plate, into position) whenever the operator sends an electric current up to the balloon from the earth. The system has the double advantage that only a small balloon is necessary, and that no risk is incurred by an aeronaut; for according to recent experience, there seems to be no difficulty about bringing down a war balloon if you can get a cannon within two thousand yards of it.

"What a capital workshop you have here!" we say; it is divided into four compartments for workmen, a broad passage running along at right angles to the divisions. "It is a very useful one," says our host, and then he adds, briefly, "I made it out of a four-stalled stable." And so he had; verily Mr. Woodbury is an inventor to some purpose.

Mr. Woodbury took out his patent for Woodburytype in 1864, but he no longer practises it in its original form; the process is now reduced to a very simple matter, Mr. Woodbury proceeds to show us. As our readers know very well, this modified process has already appeared, and what we are about to describe is therefore nothing new. Indeed, we have no doubt that anybody interested

in the subject would be quite as welcome to witness the simplified process as we were. Seeing is believing, however, and it was for this reason that we begged Mr. Woodbury to receive us.

Imprimis, Mr. Woodbury takes a piece of carbon tissue and prints a picture upon it. This picture he develops upon a piece of glass – patent plate glass. He has now, therefore, to all intents and purposes a carbon transparency, which every carbon printer knows how to produce. This carbon transparency, still on glass, is, when dry, rubbed over with a little pomatum, and then a sheet of tin-foil put upon it. The two are now run through a small rolling press, such as every photographer possesses, with the result, of course, that the tin-foil is pressed into the carbon print.

The carbon print, with its facing of tin-foil, is next carefully put into an electrotyping bath, where it is left for some hours. Copper deposits itself all over the tin-foil, and when the plate is raised from the bath, instead of presenting a shining silver surface, it is covered with beautiful red copper.

Now for the next step. A thick slab of glass covered with resin is put upon an oven or water-bath to warm. The resin melts so that the top

surface is adhesive. Under these circumstances, we take the electrotyped plate and press the copper surface firmly upon the resined glass. The whole is now cooled, and there remains attached to the glass block the copper and the tin-foil; the carbon transparency comes away. You see the sheet of tin-foil now, and find it has taken a cast of the carbon transparency, and this cast or mould, backed up by the copper and the resined plate, represents the printing block. From this printing block prints may then be taken in transparent ink, in the ordinary well-known manner.

The carbon transparency which comes away so easily, thanks to its treatment with a little pomatum, may be used again and again for the preparation of printing blocks, so that a dozen may be made, if necessary, without difficulty. No-special apparatus whatever is necessary except the actual printing-press (which is a very simple matter), and a battery. Provided with these, any photographer might begin Woodbury printing to-morrow.

An ingenious little apparatus which Mr. Woodbury has to aid him in his work deserves description. It is a veritable *multum in parvo*. It is a small iron casting, measuring about twelve inches, and its framework represents a levelling stand. Place

over it an iron plate, and below a spirit lamp, and it yields a hot plate for coating the glass block with resin. Put upon the iron plate a little oblong vessel filled with water, and there is at hand a water-bath, useful for melting the resin (a lower temperature being now necessary), to affect the adhesion of the electro plate; again, this little water-bath may be removed, and a deep upright vessel substituted, also to contain warm water, but with a grooved interior, employed for the development of the carbon prints.

Paris, it seems, has been taking up the modified Woodbury process very warmly; so little apparatus is required, and the manipulations have been so much simplified, that the photographer has it in his own hands now to multiply impressions, and print them by photo-engraving. Hutinet and Lamy, of Paris, are occupying themselves with the manufacture of the carbon tissue, &c., and photographers of high rank – like Nadar, and others – are seriously setting to work to print in Woodburytype instead of silver.

About the preparation of the printing ink, in respect to which a good deal of mystery has been made, we may mention that it is but gelatine and water with any colour added, such as Indian ink, or alizarine; in summer one-fifth to one-sixth

gelatine to water, in winter more water. The ink is kept warm in the water-bath we have spoken of.

Lastly, here is the filigrain process. "I call this the cheapest photographic image ever made," says Mr. Woodbury; he takes a carbon print developed on paper, hard and dry, of course, and sends it through the little rolling-press, in company with a sheet of plain paper. The consequence is that when the latter comes out, it has a watermark of the same design as the carbon print with which it has been pressed in contact. Any design may be thus impressed. Here are visiting-cards with the portrait of the visitor to be seen if you hold them up to the light; writing paper with all sorts of fancy designs; trade-marks, labels, &c. Filigrain, if it is the simplest, is also the most fascinating of Woodburytype applications.

Photographers working any process where gelatine is used, whether in the making of dry plates, working the carbon, Woodbury, dusting-on, or collographic processes, should be provided with a hygrometer, of some sort or other, to test the amount of moisture in the room they are working in. Mr. Woodbury has devised a very simple form, which is shown in the diagram, and can be made by anyone in a few minutes. It is constructed of

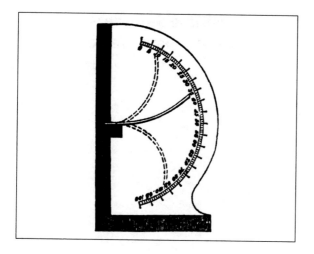

two pieces of wood, one forming a base to support the other. In the upright piece a notch is made with a fine saw, about half-way up, and in this is inserted a piece of carbon tissue, about four inches long and an inch broad. At the back is tacked a piece of card with a scale marked on it, the lowest number representing 100, and the highest zero.

With a moderate amount of moisture, the paper will remain almost horizontal, in a very damp atmosphere will take the curve of the lower dotted line, and in an excessively dry state of the air will curl upwards as in the higher one. In combination with thermometric observations, probable changes in the weather may also be foretold by it.

Hills & Saunders
at Porchester Terrace

Some years ago, when cabinet pictures were more of a novelty than they are now, a practised amateur of our acquaintance used to exhibit on his mantelpiece two well-finished prints which he considered representative photographs of English and French portraiture. The one was bright, clear, and well modelled, a cabinet portrait from Reutlinger's studio on the Boulevard Montmartre; it represented one of the actresses of the *Palais Royale* and although, no doubt, a good deal of retouching had been done to the negative, the picture was full of esprit and "go", and altogether a delightful result to look upon. The British portrait did not pretend to such vivid clearness; it was more sketchy than vigorous, and was soft and delicate to a degree. It was that of a lady in a deer-stalker's hat, with fair curls, the features rounded, and the hair as soft as silk – a happy portrait of the late Miss Amy Sheridan, and the work of Messrs. Hills and Saunders. Messrs. Hills and Saunders have always taken high rank in London. They may be found "at home" at other places besides Bayswater, at Eton, Aldershot, Sandhurst, Oxford, and Cambridge; but the studio in Porchester Terrace is, we believe, the head-quarters. We have said studio, but the word is something of a misnomer. Any casual passer-by would

fail to recognize the exterior as that of an eminent firm of photographers, and when the visitor has rung the bell and been ushered into the drawing-room, the fact is no more apparent. There are a good many photographs on the walls, and several albums on the table, but scarcely more than you would find in the reception-room of a private gentleman. If Messrs. Hills and Saunders will excuse the remark, there seemed to us an amateur-business-like aspect about the place, which certainly had this effect, that it set the visitor at his ease, and did away with all formality and nervousness.

The enlargements to be seen were none of them on a very large scale, but all exhibited a soft, pear-like tone that was difficult to understand at the first moment They were one and all pictures upon porcelain, or, rather, pot-metal. Some were by the carbon process, the medal picture to which we have just alluded being one of these; but the majority had been secured by the aid of the powder process. Finely-grained opal glass was the basis in all cases, the ground surface permitting the artist to touch with stump or brush without previous varnishing. The powder process practised by Messrs. Hills and Saunders does not differ in the main from that detailed by Mr. Valentine Blanchard. But there is this

particular precaution to be taken, Mr. Cowan tells us (whom, by the way, by a breach of good manners, we have failed hitherto to introduce to our readers), namely, that hand-ground opal is chosen. A cheap form of grinding has lately been introduced, by directing a blast of fine sand against the opal surface, which, however well it may answer for other purposes, is not suitable for the preparation of a glass surface that is to serve for photographic work of this kind. The sand particles are not equal in their action, and the consequence is that the surface is pitted here and there. It requires no magnifier to show these minute cavities, which can be well seen on closely examining a glass surface held horizontally towards the light, and pigment lodged in these cavities is very apt to leave the glass surface subsequently; a hand-ground plate, on the contrary, has a matt milky appearance; with a surface perfectly free from such imperfections.

The cabinet portrait is the favourite format still at Porchester Terrace, and Mr. Cowan, in turning over the leaves of a large album, showed how the backgrounds in every case were different. "Oh, I know where you had that taken; that's So-and-so's background!" is a remark not unfrequently heard; but at Bayswater, by the simple arrangement of a

few ferns, dried palms, grasses, and rustic fence-work, no two pictures are ever alike. Moreover, if it is a question of enlargement afterwards, these grasses, &c., help to avoid a lot of retouching.

Leaving the drawing-room by folding doors, you pass through an ante-room into what was evidently a conservatory once upon a time, but is now a well-lighted glass-room of wonderful capacity. Here again the visitor feels at his ease; there is no trudging up a flight of stairs, and getting hot and flurried in the process; you might pass into the studio without knowing it, if it was not for a curious sort of camera that stands in the path, and never takes his glassy eye off you. "We'll tell of you, my fine fellow!" was the idea that occurred to us, and we shall now do so.

This camera lives alone by itself. Mr. Cowan told us in confidence, and we repeat the secret under the same reserve, that there was no other camera in the studio. This is not, we believe, because Messrs. Hills and Saunders' means are inefficient to provide a second instrument, so much as that the one now in possession of the floor of the studio has no rival. We ourselves observed him work his optic more than once, without any visual agency, just to intimate what he could do when he

tried; while his ability to secure a carte or cabinet or a ten-inch plate is only equalled by the readiness with which the base-board can be elongated, and his body converted into a copying-camera, when he goes on reproducing *clichés* without making the least difficulty about it. Despite its solidity, this occupant of the glass room turned with considerable ease; near its foot were two cells of an electric battery which supply its vitality, and cause either a drop-shutter to fall, or a cap to be lifted, in obedience to its master's wish. The latter, provided with electric wires, may, as in the case of the Cadett shutter, move to some distance from the camera, and approach and talk to the sitter while he exposes his plate. To describe intelligibly the clever electrical arrangement which Mr. Cowan has ingeniously brought to bear would be impossible, nor would it serve any useful purpose, since to use such an instrument a man must be something of an electrician, and if he is this, he would probably do his best to contrive a plan of his own. The making and breaking of contact and magnetising and de-magnetising of a piece of iron, is, of course, the principle upon which the actions rest; most people know that if you twist wire round a bit of soft iron, this soft iron will become a magnet any time that

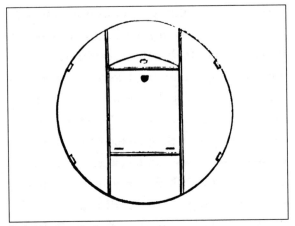

Figure 1: The camera back

an electric current passes through the wire. The electric current, in encircling the iron, magnetises it; break the current, and on the instant the iron loses its magnetic virtue. Mr. Cowan simply makes use of electro-magnetism, or magnetism evolved from electricity, to work his camera.

Cabinet and carte plates are made inter-changeable in a simple way. The back of the camera is a flat circular disc which revolves; it is, in fact, very similar to a turntable on a railway, only it is perpendicular instead of being horizontal. There are a pair of rails – or grooves, rather – running across the turntable and into these grooves is slipped the dark-slide. If a cabinet

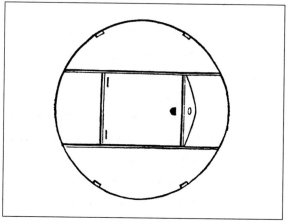

Figure 2: The camera back

is wanted the plate stands on end (Figure 1).

If cartes are desired, the table is turned, and the dark-slide stands ready for securing three cartes (Figure 2).

The glass-room may be said to be two rooms joined at right angles, and so favourably situated in respect to a north aspect, that it is frequently possible to work without blinds at all. A blue banner screen, some two feet square, stretched stiff, and borne upon a pedestal, so that it may be suitably adjusted over the head of the sitter, is in some cases the only shade employed in the studio. Mr. Cowan has no great faith in Seavey's backgrounds; his own, he tells us, are, for the most part, painted

for five shillings a-piece, by an old hand who has been a scene-painter in his day. Rather than the conventional drab-grey usually affected in backgrounds, a warm brown or brownish-grey is the tint preferred. The backgrounds are of various kinds; there is one with rollers top and bottom, an endless panorama; others moving in grooves, as if they were wings at a theatre; and a third description that is hinged, and acts like a practical door.

We were shown the properties wherewith all the rustic changes to be seen in Messrs. Hills and Saunders' cabinet pictures are carried out. Hay, dried grasses, dead palm leaves, together with a few growing plants in pots, and some branches and twigs, comprised the whole. "We throw nothing away," said our host, taking up a brown palm leaf from the floor; "we only take care to change the arrangement with every picture."

We have scarcely time to speak of the laboratory and darkrooms. Gelatine plates are in constant requisition at Porchester Terrace, but so are wet plates. The ordinary dipping bath is not to be seen at all here; the sensitizing baths are of a horizontal character, swinging on pivots, of the same nature as those at the Autotype Company's works. The interior is of paraffined wood, and they possess the

advantage that less silver solution is needed, while the plates are permitted to drain more effectually.

"One guinea for the sitting, which must in all cases be paid at the time," is a notice we extract from the card of Messrs. Hills and Saunders, and for this guinea the sitter may take his choice of twelve cartes-de-visite, twelve vignettes, twelve medallions, six cabinets, or four boudoir pictures. Proofs are generally sent out the same evening, but always in an untoned and unmounted condition.

Captain Abney
at South Kensington Museum

In a remote corner of the vast establishment which has grown up of late years at South Kensington, among the workrooms and repairing lobbies, where works of art, statuary, models, pictures, &c., are set up, and generally put to rights, prior to their admission into the bright galleries of the Museum – behind the scenes, as it were, of the spectacular entertainment which is provided for the London public on such very cheap terms – is to be found one of the laboratories of Solar Physics. To come upon this laboratory, as we did, after traversing a quarter of a mile of brilliant glass cases and polished floor, of pleasant pictures, shining vases, and gorgeous war trophies that tempted one to linger at every step – to be ushered, we say, after this, into a sort of backstairs and lumber room department, was not agreeable. There was a cold, draughty, unfurnished look about the place, that caused you to wish yourself back again in the Museum itself; and it wanted all Captain Abney's warm reception and welcome to dispel these very unpleasant feelings.

To say that Captain Abney was busy photographing the red end of the spectrum, when we entered, need scarcely be set down; it is but a matter of course. "We believe, in fact, that the region of the red is now universally admitted to be his own private

domain; at any rate, there are very few physicists who would care to dispute the matter with him.

It is not so long ago, despite Sir John Herschell's dictum, that the photographing of the lines in the red end of the spectrum was regarded as an impossibility; but, thanks to our advanced physicists, and particularly to Captain Abney, the ultra-red can now be recorded upon a photographic plate, if not as readily, at any rate as accurately, as the violet and ultra-violet portion of the spectrum.

His present investigations are confined to photographing light through various media, such as water, alcohol, glycerine, &c. Just now it is water, and he passes his light through a column of this medium no less than five feet in breadth. There is a long table; at one end shines an electric light, and the rays from this light are thrown by means of a condenser in a horizontal direction through a long tube, also placed horizontally, filled with water. At the end of this five-foot tube is the slit of the spectroscope, Captain Abney employing on the present occasion as many as five prisms to refract the rays; and at right angles to the spectroscope is the camera. We can see the red end of the spectrum limned in soft delicate colour here on the focussing screen, and remark how intense the ruddy glow is

in the centre of the image; it is, of course, but an accident that Captain Abney's assistants should be attired in the same colour, but the scarlet-coated Sappers, as they move about with dark slide or lens, are all in harmony with the experiment.

There are two openings in the wall of the laboratory, which appear at first sight like tiny windows; they are condensers for the purpose of employing solar light; and looking out into the open, you see beyond, the pedestals whereupon stand the heliostats, which keep pace with the motion of the sun, or rather, of the earth, and permit a constant ray to be reflected into the laboratory through these condensers for hours together. In this way you may avail yourself very conveniently of the sun when it shines, and carry on solar work with a degree of comfort and convenience that experimenters do not always enjoy in pursuing their physical researches.

The darkroom of our photo-chemist is capable of all sorts of lighting. The collodion emulsion employed for photographing the red end of the spectrum appears to be more sensitive than the gelatine film, and very little light indeed is em-ployed during its manipulation. So far as gelatine work is concerned, we may inform our readers

that Captain Abney employs a gas jet with a glass globe, which globe is painted with a mixture of aurine and aniline scarlet applied by the aid of negative varnish. The aurine is an efficient substitute for yellow or orange, and the aniline scarlet for ruby glass or fabric, a combination which, as most of us know, is very effective in cutting off troublesome rays from the gelatine film.

Captain Abney has taken a leaf out of Mr. England's book, in the preparation of gelatine plates, and possesses an efficient cupboard of the England pattern. He gives the England cupboard a very good character, and has no difficulty in maintaining a constant temperature of something like 75°F, which dries the gelatine plates effectually.

After developing, and before fixing, our host makes it a practice to dip his gelatine plates into a saturated solution of alum; he prefers operating in this way rather than fixing the negative first of all. His development is carried out in white dishes of enamelled iron. They are somewhat after the shape of a Yorkshire pudding dish, and, besides being unbreakable, they have the advantage of showing when they are dirty and when they are clean.

Here is Captain Abney's method of preparing collodion emulsion sensitive to the infra-red

region of the spectrum. He says: "A normal collodion is first made according to the formula below:

Pyroxyline (any ordinary kind)...16 grains
Ether (.725 s.p.)4 ounces
Alcohol (.820)2 ounces

"This is mixed some days before it is required for use,and any undissolved particles are allowed to settle, and the top portion is decanted off. 320 grains of pure zinc bromide are dissolved in 1/2 ounce to 1 ounce of alcohol (.820) together with 1 drachm of nitric acid. This is added to 3 ounces of the above normal collodion, which is subsequently filtered. 500 grains of silver nitrate are next dissolved in the smallest quantity of hot distilled water, and 1 ounce of boiling alcohol .820 added. This solution is gradually poured into the bromised collodion, stirring briskly whilst the addition is being made. Silver bromide is now suspended in a fine state of division in the collodion, and if a drop of the fluid be examined by transmitted light, it will be found to be of an orange colour.

"Besides the suspended silver bromide, the collodion contains zinc nitrate, a little silver nitrate, and nitric acid, and these have to be eliminated. The collodion emulsion is turned out into a glass

flask, and the solvents carefully distilled over with the aid of a water bath, stopping the operation when the whole solids deposit at the bottom of the flask. Any liquid remaining is carefully drained off, and the flask filled with distilled water. After remaining a quarter-of-an-hour, the contents of the flask are poured into a well-washed linen bag, and the solids squeezed as dry as possible. The bag with the solids is again immersed in water, all lumps being crushed previously, and after half-an-hour the squeezing is repeated. This operation is continued till the wash water contains no trace of acid when tested by litmus paper. The squeezed solids are then immersed in alcohol .820 for half-an-hour to eliminate almost every trace of water, when, after wringing out as much of the alcohol as possible, the contents of the bag are transferred to a bottle, and 2 ounces of ether (.720) and 2 ounces of alcohol (.805) are added. This dissolves the pyroxyline, and leaves an emulsion of silver bromide, which, when viewed in a film, is essentially blue by transmitted light.

"All the operations must be conducted in very weak red light – such a light, for instance, as is thrown by a candle shaded by ruby glass at a distance of twenty feet. It is most important that

the final washing should be conducted almost in darkness. It is also essential to eliminate all traces of nitric acid, as it retards the action of light on the bromide, and may destroy it if present in any appreciable quantities. To prepare the plate with this silver bromide emulsion, all that is necessary is to pour it over a clean glass plate, as in ordinary photographic processes, and to allow it to dry in a dark cupboard.

"For development of exposure I recommend what is known as the ferrous oxalate developer. This is prepared by dissolving ferrous oxalate in a saturated solution of neutral potassium oxalate, adding the iron salt till no more is taken up. To make up the developing solution, equal parts of this solution of ferrous oxalate, and of a solution of potassium bromide, 20 grains to the ounce, are employed. This mixture is placed in a clean developing glass just before development takes place. The film is first softened by flowing over it a mixture of equal parts of alcohol and water, and is then well washed. The developer is now poured over the plate, taking care to keep the fingers from touching any part of the film. The image will appear gradually, and should have fair density when all action is exhausted.

"The intensity can be materially increased by using the ordinary intensifying solutions of pyrogallic acid, citric acid, and silver nitrate. The unreduced silver bromide is removed by a saturated solution of sodium thiosulphite in water, from all traces of which the film should be thoroughly washed before being allowed to dry.

"The operation of development should take place in a very subdued red light, that recommended for the preparation of the emulsion being the safest. It is, however, somewhat remarkable that when the developing action has once been set up, a greater quantity of light may be permitted to fall on the plate than before the action commences. The bromide of potassium probably prevents any further action by the light, which may account for it. It should be noted that the image may be developed by the ordinary alkaline method, though not so satisfactorily, a slight veil being usually apparent.

"I may here state that by diminishing the amount of nitric add to one-fourth the amount given in the preparation of the emulsion, it is possible in very cold weather to obtain plates which are sensitive to very low radiations, such as the radiations proceeding from boiling mercury, or even boiling water. In summer time this emulsion,

as would naturally be expected, produces what are known as "foggy pictures"; but it can be rendered of use by flooding with hydrochloric acid. In the preparation of such an emulsion the water bath must be kept at a temperature but little above that of the boiling point of the ether."

Valentine Blanchard
in Regent Street

In the neighbourhood of Fleet Street there have established themselves for several years past a body of gentlemen known by the name of the Whitefriars Club. This club is not a large one, and has never, we believe, since its commencement, numbered more than seventy or eighty members. It is for the most part a literary club – its predilection for the neighbourhood in question indicates as much – and amongst its past and present members may be cited men of considerable mark. Novelists, such as William Black and Charles Gibbon; editors of the great London dailies – to wit, Captain Hamber and Alfred Bate Richards; conductors of humorous periodicals that enjoy scarcely less influence in the country, the late Tom Hood of *Fun*, and William Sawyer of *Funny Folks*; actors of the first rank, like Barry Sullivan and William Creswick; painters and cartoonists, such as Orchardson, R.A., and John Proctor; these, to cite a few examples, are upon the roll of Friars. But the Club, noted as it is for the long list of talented men enrolled under its name, is famous in one other respect: it possesses, beyond question, the finest gallery of photographic portraits to be found in any hall or room in London. Probably, the collection does not at this moment fall short of half-a-hundred,

and the pictures are all of them of magnificent proportions, taken direct on 15 by 12 inch plates – vigorous, lifelike, and characteristic. Moreover, they are all of them the work of Mr. Y. Blanchard.

In a word, no better evidence of Mr. Blanchard's ability can be afforded than this fine collection of portraits at the Whitefriars Club. It shows, too, the school, or style, of portrait, for which Mr. Blanchard has achieved a very extensive reputation. His large direct portraits – massive, dignified, full of life – are, indeed, too well known to require any detailed description here, for every visitor to the Pall Mall Exhibitions during the past half-dozen years must have witnessed examples of his handiwork. Mr. Blanchard is, to some extent, a disciple of Adam-Salomon, the late well-known sculptor and photographer of Paris; but he has added to his portraits qualities which are personal to himself. The rich, luscious shadows of the Adam-Salomon school are present, together with other attributes inherent to Mr. Blanchard himself. We do not mean to say that the latter's portraits are better than those of his illustrious Paris confrère, but that, equally with Adam-Salomon's pictures, they have characteristics which mark them as the work of an artist in the foremost rank.

Mr. Blanchard's reception-room has but few pictures upon the walls, but they are well chosen examples of his best work. The most striking are *Rebecca at the Well*, a fine Eastern study, which secured a medal at Pall Mall, and the picture of a Greek girl, that received a similar honour. In both of these pictures the management of the drapery is beyond praise; it falls in soft and graceful folds over the figure, without marring the outline of the latter. The Greek key pattern on the tunic of one of the models was pencilled by Mr. Blanchard himself, for he found that the addition of an edging or braiding to the drapery imparted a stiffness which was very objectionable to the picture. Miss Fortado, as Esmeralda, is another study Mr. Blanchard may well feel proud of, and some manly portraits on 15 by 12 plates complete the collection. Mr. Blanchard's charge for these pictures is £4 4s.; for cabinets, £2 2s. per dozen is asked, and for cartes, £1 1s.

The studio upstairs, at first sight, impresses one in a very singular manner. Instead of being light, it is dark. Indeed, there is little doubt that Mr. Blanchard employs less illumination than most of his brethren; he objects to flood his models with light. Half-a-dozen movable screens are about the studio, standing some eight feet in height, and measuring

six feet in breadth. These are put about with very little ceremony. "My light here is dead south," said Mr. Blanchard. "If I get bothered with the sun coming in, I simply stop the light from this portion of the studio, and go over there with my camera, where the light is easterly." And in a moment, our host had contrived by means of his screens a second studio at right angles to his first. "I consider," said Mr. Blanchard, "that the most perfect lighting a photographer can have is when the sun is obscured by a white cloud, and I endeavour to imitate this phenomenon in my studio. You see I have subdued illumination all on this side, and admit pure light only through two or three squares of glass."

Mr. Blanchard has an excellent plan for subduing his illumination. The side and roof, where it is of glass, and where the light is to be softened, are furnished with transparent screens of a movable character. In cloudy weather they are not needed; in sunshine they are. These screens are covered with *papier minéral*, which has the appearance of fine ground glass; the *papier minéral* has the advantage over ground glass of being far cheaper, and much lighter to handle. "English tracing paper won't do," says our host; "it goes yellow after a few weeks, and then goodbye to your white cloud effect; you get

a yellow glare then, which is very unpleasant."

Mr. Blanchard has been working the powder process to good effect in producing pictures on opal. His formula is:

Dextrine 4 drams
Grape sugar 4 drams
Bichromate of potash 4 grams
Glycerine 2 drops
Water 12 ounces

This is applied twice to the clean opal plate, carefully drying by heat in between; then, says Mr. Blanchard, the plate is ready for the printing operation. To make a print on the bichromate film, which should be even and bright, and of a deep yellow colour, a transparency, not a negative, is necessary. This transparency must be inverted, and, therefore, a print on glass by direct contact with the negative will not do. The transparency must be made in the copying camera, and care must be taken that the negative have the film side away from the lens. This transparency, in order to give the best result in the after-process of print-ing, should be very delicate and full of detail, but with clearness in the highest lights – in fact, bright as well as delicate – or the print will be dull and

wanting in harmony. It is best to varnish the transparency for fear of accident, but it is not absolutely necessary. Now whilst the prepared opal is still warm (after the drying operation), lay it with film upon a board covered with dark velvet, and carefully place the transparency, which should also be warmed, with the film down on to the opal. Care must be taken to place it so that the head comes in the proper place on the opal. It must now be carried into the light, and exposed to clear *bright* light, not necessarily sunlight. Were this the same always, it would make the timing of the exposure much more simple. But it is impossible to indicate the exact exposure; this can only be found by experiment. After a little practice, it will be possible to judge by the amount of browning which takes place, for the bright yellow after a time gives place to a brown, not unlike ripe corn. From two to ten minutes in a dull light, or a few seconds in sunlight, will be found sufficient. When the plate is taken back to the darkroom, and the transparency removed, a faint image will be visible. The development is brought about by the employment of any finely-ground pigment, such as ivory-black or in indian red, in combination with black in suitable proportions to satisfy the taste of the operator.

Now apply the powder by the aid of a large camel-hair brush, beginning on a portion of the dress, or in the shadows of the hair, and not on the face. Should the powder attach itself too readily, and the camel-hair pencil appear to drag at all, the film is too tacky, and it will be better to shake off the powder and slightly warm the film before proceeding further. On the contrary, should the powder refuse to adhere after gently rubbing with the pencil for some little time, shake off the powder and gently breathe upon the plate, and move it backwards and forwards until the moisture has evaporated, and again apply the powder as before. This operation may be repeated until the image is sufficiently brought up. If the exposure be too short, the powder will too readily attach itself, and the image will be muddy and wanting in contrast; whilst, on the other hand, if the exposure be too long, the image will be too much defined on the opal, and the powder will refuse to adhere even after a lengthened application. When, however, the exposure has been rightly timed, the powder will attach almost immediately, and a clear image will readily be developed. If, however, after varied exposures the powder refuses to adhere, it may be well to increase the proportion of the grape sugar in the solution,

and the use of the separate solution of grape sugar mentioned above will be at once apparent.

The plate is now ready for fixing. This is accomplished by pouring over saturated solution of boracic acid in alcohol. After carefully drying, the plate must now be carefully soaked in a dish of clean water. After a few changes, to wash out the bichromate, the plate may be taken out and dried, and the picture is ready for the artist. If, on trying the plate with the finger, the powder be easily rubbed, the plate must be immersed for a few minutes in a bath composed of sulphuric acid two drams, water one pint. After a few changes of water the plate may be again dried.

Mr. Blanchard's copying camera for making his transparencies for the process is simple in the extreme. There is a long plank upon which the camera stands; at a little distance in front of the lens stands an upright board with a perforation in which the negative is placed. Beyond the negative, again, is a bit of white cardboard, or paper, sloping at an angle of 45°. The white paper reflects the light through the negative; and before focusing, a black cloth is simply thrown over the camera and over the upright board that carries the negative in order to shut out the light. This is the whole arrangement;

there is no condenser, a No. 1 or No. 2B lens being employed for copying; and the apparatus has the inestimable advantage that it can be cleared out of the way in an instant, and rigged up again without delay, trouble, or expense.

Robert Faulkner
in Baker Street

This is the kingdom of Lilliput. From the walls look down upon you tiny forms and chubby faces; they smile or pout, are roguish or coy, bright or tearful, under the gentle sway of the silvery-bearded monarch who here reigns supreme. Like the pied piper of Hamelin, Mr. Faulkner can do as he pleases with his little people. It is not a question of obedience; it is an innate-power he possesses, which renders them subservient to his will. We all of us have heard the German legend: how the pied piper was engaged by the village mayor to get rid of the rats, and having performed his task, got laughed at for his pains; how, in revenge, he went away playing upon his pipe so sweetly, that all the children, great and small, were perforce compelled to follow him; how he led them into a chasm in the mountain side, which closed upon the pigmy procession, so that the children were never seen again. Only one little fellow escaped – he was lame, and could not hobble along on his crutches so fast as the other children. He was shut out by the rock, and remained to tell the story. So, apparently, Mr. Faulkner has only to exercise his will to make his tiny subjects follow him. In his hands they are not only plastic as clay, but smiles and tears, humour and pathos, are called up in

the little faces at his bidding. Let boys and girls be ever so stubborn, Mr. Faulkner has but to breathe his spell, and they follow him. As Goethe has it:

Und waren Knaben noch so trözig,
Und waren Mädchen noch so stützig
In meine Seiten greif ich ein,
Sie müssen alle hinter drein.

It is not easy to get beyond the reception room. The merry dimples and winsome faces are for ever luring you to stay. Here is a little miss, in mob cap and loose gown, with curly locks and pensive look, who seems to hare strayed out of a picture by Sir Joshua Reynolds. Here is a tiny being, her eyes as black as sloes, who has put up her bare arms behind her round head, and beams wickedly across to you. Here, a fair-haired urchin in the guise of a petty officer, looking every inch a sailor; and here again a study, of which Mr. Faulkner is justly proud, the *Infant Samuel*, whose upturned face is full of pathos and devotion.

Passing on, we enter a spacious gallery, in which are larger examples of Mr. Faulkner's work. Mr. Faulkner believes that a carte or cabinet negative is sufficiently large for most purposes, And

his bigger pictures are all taken from these. Mr. Faulkner has a high opinion of powder pictures, but, unfortunately, he says, there is no one to whom the retouching of them can be trusted. A clumsy or ill-judged touch of the brush upon a delicate cheek or softly-moulded dimple will ruin the picture, and he now prefers to print his enlargements by the carbon process, confining the work of the retouching brush to simple "mending". "There is not five shillings' worth of retouching work on any of these pictures," said Mr. Faulkner, pointing to a fine series of studies, of which many have been published with marked success. A transparency is produced in the first place, and it is upon this transparency that depends the value of the finished work. Mr. Faulkner can bear out the adage, "If you want a thing done well, do it yourself," since he is compelled to produce every one of his transparencies by his own hand. But he has the great consolation of knowing that he is successful. Of some of his studies printed in "red chalk" carbon, no less than 10,000 copies have been sold, for Mr. Faulkner appears just now to have the monopoly of producing sketches of this nature, which are highly prized and eagerly purchased by painters and sculptors, as well as by the general public.

Mr. Faulkner speaks highly of gelatine plates for making reproductions, the soft, subdued character of the image yielded by a gelatino-bromide film being specially applicable to such work. For all his studio work, gelatine plates are also employed, and Mr. Faulkner's establishment is one of the few in which the silver bath has been wholly and completely got rid of.

We will walk upstairs into the glass room, for our readers are doubtless eager to learn all they can of Mr. Faulkner's method of treating his infant sitters. Our host courteously affords every information. How does he arrest their attention, call up that glow of intelligence in their faces, and give that vivid animation to their features, we ask; is it a matter of toys, or conjuring, or story-telling? "A ball is the best of all toys," replies our host; "this cow that gives real milk, often provokes wonder"; it is a toy treated Abyssinian fashion, a steak being removed from one of the flanks in order to permit the introduction of the milk in the first place; "but one must rely a good deal upon one's sayings and doings."

The camera and stand must be described. The stand is of iron to give solidity, and upon it are placed, one above the other, two cameras of

almost equal size. The ground glass of the upper camera can be seen without stooping, and hence the focussing is done with the greatest ease. A guard or screen, permanently fixed, throws the ground-glass into shadow, and there is no occasion, therefore, for a dark-cloth. The cameras are fixed together; hence one focussing arrangement does for both. The lower camera only receives a dark slide, the upper one is employed simply for focussing and watching the sitter; in a word, the upper camera acts as a "finder". Under these circumstances, as may be understood, the operations go on with smoothness and ease. There is no dark cloth, no pushing on one side the focussing screen to admit the entrance of a dark slide. There is a sensitive plate always ready in the lower camera, and no sooner has the model taken its seat than the operation may begin. The slide holds a plate large enough for four or six portraits, and if one of these is successful, Mr. Faulkner holds himself a happy man.

A movable pedestal, eighteen inches from the ground, serves as a platform whereon to pose the model. The sitter may thus be presented to the camera under one aspect or the other, without being troubled to move at all, and the photographer

standing behind the cameras watching his opportunity has every chance in his favour. Often the sitter, immediately it sits down, is at its best; while under ordinary circumstances, the model has to obey twice, namely, at the time of focussing and the time of exposure, and sometimes gets so fatigued over the former operation that it has lost all animation during the latter; Mr. Faulkner, by the assistance of his movable platform and double camera, is enabled quickly to seize any and every favourable opportunity that presents itself.

That Mr. Faulkner is an artist of a high order, and stamps his work with the imprint of his genius, is known to all who are familiar with his work, and obviously we cannot follow him very far, unless we too possess the same attributes. But we can all of us do our best, if we like, and a visit to Mr. Faulkner's establishment shows how much may be done in photography if one is gifted with taste and endowed with application. Mr. Faulkner's studio has little in it that is remarkable, but he employs, as we have seen, his means to the best of his ability. The lighting is of a very simple character. A skirting board rises five feet from the floor, and there is no top-light. The side where it is glazed is of large sheets of transparent

glass; but this is used with the utmost modera-
tion. Blinds are freely drawn near the camera,
and in the vicinity of the sitter large squares of
transparent paper may be made to cover the glass.

Mr. Faulkner has no other models than the little
sitters who come to him in the course of business.
The delightful studies in red chalk that he pub-
lishes in such large numbers are simply selections
from his negatives. He pays, however, much atten-
tion to the dressing – or, rather, undressing – of
his models. This little garment, we see, appar-
ently of yellow silk, it is so soft and glossy, is but
fashioned out of fine calico, the edges frayed, not
hemmed, and dipped roughly into a little Judson's
dye to give colour. Dressed in this simple tunic,
no wonder the pink arms and legs of the model
appear to such advantage, and that the drapery is
rendered with such harmony and detail. But Mr.
Faulkner has a grievance: he is dissatisfied with the
printing processes of today for small work. Carbon
printing, he avows, is not at the present moment
sufficiently advanced for the printing of cartes, al-
though it answers so admirably for larger pictures.

The only thing that can give us the full amount
of delicacy and permanence, in Mr. Faulkner's
opinion, is collodio-chloride paper. "I have an

album downstairs, which I will show you, in which all the prints are fifteen years old; they are mounted on plate paper, and therefore should be the last to show traces of fading. But in that book there are only two pictures in which these traces cannot be recognised; the one is a Wothly-type, the other a collodio-chloride picture."

As to the delicacy furnished by albumen and collodio-chloride, there is no doubt as to the advantage being on the side of the latter. Before the prints go into the fixing bath, the albumenized paper prints will doubtless compare well enough with collodio-chloride, but the fixing bath removes fine gradations from the albumen surface; the collodio-chloride, on the other hand, is not attacked by the hyposulphite solution, and retains all the delicate gradations with which it has been impressed during the printing operation. But collodio-chloride paper cannot be purchased fresh and new in this country. "The Germans have makers of collodio-chloride paper in their midst; cannot we find a single manufacturer of photographic materials enterprising enough in this country to give us what we want?" asks Mr. Faulkner.

The Van der Weide Electric Studio in Regent Street

The lamps in Regent Street are lit, for the light fades early these short wintry days. It is still afternoon; the Quadrant is full of life; the gay costumes of the promenaders, now veiled in the mist of twilight, now made resplendent by the vivid illumination of the shops, lose none of their attraction, but, on the contrary, seem enhanced rather "between the dark and the daylight when the night is beginning to low'r." Longfellow is not alone in loving the period; we believe every thoroughbred Cockney rejoices in this time between the lights, and it is the one thing that reconciles him to winter when it comes upon us. There is a feeling of warmth, of cosiness, of brightness, of snugness prevailing at such times, which dwellers in great cities always delight in, and which may be considered a set-off against the many advantages our country cousins enjoy.

"I like to stroll down Regent Street," says the song, and between afternoon and evening the sentiment appears to be a very popular one. It is Cattle Show week, and this may have something to do with augmenting the busy crowd of loungers that hustle one another upon the glimmering pavement before the bright shops and under the glittering lamps. It may not be "the season" in town; but London is full, for

all that, and so bustling and animated a scene is rarely found at any other time of the year.

It is hardly a seasonable hour to visit a photographic studio, one would think; but we have purposely delayed our call. The card of invitation says any hour before 7.30pm, so we are in plenty of time. Mr. Van der Weyde's studio is in a magnificent position in the very centre of Regent Street; and, of what Mr. Van der Weyde is very proud, it is under a slate roof. There is not even a skylight, lest the suspicion should gain ground that sometimes daylight is employed for photographic purposes. The Van der Weyde establishment is a winter studio *par excellence*, it might be said, only that, curiously enough, it is in summer when most of the work is done, for the simple reason that the London season is during the longer months. What strikes one, indeed, in looking over the portraits here, is that so many persons should be represented in evening dress; but the mystery is solved by the explanation that the ladies and gentlemen in question have been photographed in the evening before they sat down to dinner, or maybe after they came home from the opera. It is but the other day we read of the Prince of Wales being photographed, after having first passed the

evening at the play; while it is not so long ago that
Mr. Van der Weyde had a call from Captain Shaw,
of the Fire Brigade, accompanied by a certain duke
whose fire-loving qualities are well-known, the
visitors arriving at midnight, and not departing
till one in the morning. Whether they came to see
if the electric studio were on fire is a moot ques-
tion, but certain it is they were not permitted to go
till some very excellent portraits had been taken.

Mr. Van der Weyde's series of Royal pictures
is a large one; but, fine as it is, the collection of
"professional" portraits he has made is the most
attractive. Perhaps ladies and gentlemen who are
in the habit of appearing before the footlights
make better pictures with artificial illumination.
Here is a portrait of Josef Gung'l, the composer;
here is Toole, the comedian; here is Edwin Booth,
and here is Henry Irving. All are clear, forcible,
and brilliant – well lighted, and agreeably posed.
Mr. Van der Weyde has discarded the dioptric or
"lighthouse" lens he formerly employed, and of
which a description was given some years ago.
His electric light has a brilliancy equal to 6,000
candles, and is produced by a Gramme, or Siemens,
machine, as may be found most convenient, for
both systems find a place in the engine room. The

engine is one of Otto's gas engines, Mr. Van der Weyde, we believe, having been the first to apply a gas engine to the evolution of electricity.

Mr. Van der Weyde, in explanation of his light, said: "I had my gas-engine put up September, 1877, in direct opposition to the advice of the manufacturers of my electric machine. I never use an electric lamp, but, as you see, have invented a much more practical arrangement for my purpose. I simply bring my carbons together by a movement of the hand. The positive 20 millimetre carbon is stuck right through the saucer, and can be pushed in from time to time as it burns. The negative 15 millimetre carbon, fastened in a rod which passes through the back and centre of the reflector, is also adjustable. The saucer and positive carbon, being fixed to a flexible brass rod, can be made to approach the other carbon by simply pulling the cord attached, and which passes through the back of the reflector, and over a small drum. I first designed another position for the carbons, but on the same principle, but find this better, as the reflector gets the full benefit of the strongest rays."

We walk into one of the studios. The most prominent object is a large cup-shaped reflector, in the middle of which, is the electric light. This

reflector is five or six feet in diameter, like the half of a huge globe, the interior being of white paper; it hangs loosely from the ceiling, and is provided with a handle, so that an assistant, who holds it the while, can direct the light as he pleases. As a rule, it reflects the light downwards on the sitter at an angle of something like 45°. The electric glow of the carbon points is not seen by the sitter, because a little saucer, situated just below the spark, intervenes, throwing the light upwards into the parachute reflector, whence it is reflected upon the sitter. Mr. Van der Weyde does not cover in his electric light by means of a sheet of thin paper (giving it the form of a kettle-drum inverted), as do M. Liebert, of Paris, and the Stereoscopic Company, but employs the full force of the light without subduing it by a medium. He is thus enabled to make very quick exposures. Cartes of children are secured in one or two seconds; while the cabinet portraits and prom-enade portraits, which are Mr. Van der Weyde's speciality, require but from six to seven seconds, gelatine plates being, of course, made use of.

The sitter is surrounded by white screens dur-ing the exposure, except, of course, on the side of the reflector; there is even a screen in front of the

sitter, pushed, in the case of a vignette, within a foot or eighteen inches of the model, an opening in the latter screen permitting the camera to peep through. There cannot be a doubt that, under some circumstances, a front screen – such as this – especially if it had movable wings, or reflectors at sides, top, and bottom, might be advantageously employed for daylight portraits.

A young lady is ready posed as we enter. Mr. Van der Weyde himself arranges the model, and directs the lighting. One assistant, holding the reflector, obeys his directions, while a second focuses, and makes the camera ready. The portrait is to be a profile, illuminated by an edge light, and the reflector is so turned that the white screen at the back – which serves as background – is cast somewhat in the shadow. We peep through the camera opening, and the effect is delightful. The lady is young in years and comely in face, and, as she sits there, the pure electric light flooding face and shoulders, and brilliantly illuminating her features, we are reminded of the good fairy in the enchanted island of dazzling light, or the pretty princess of the realms of brightness, with whom we all become acquainted about Christmas time.

In practised hands the reflector permits of a

wide range of lighting, and it is the effects thus obtained that have had much to do with the success of the Van der Weyde portraits. Again, instead of being hard, or black and white, the fault inherent, one would think, to artificial lighting, the pictures, by reason of the skilful lighting, are soft to a degree, and Mr. Van der Weyde tells us he has never to retouch a highlight.

A little incident of the studio may here be mentioned. The lady would like a second picture, without her bonnet. There is no need to get up and go away to arrange her hair or head-dress; an elegant little toilet table on castors, with mirror and brushes, is pushed towards her chair, and, without moving, she can make her toilet as comfortably as in a boudoir. Not only is the lady not inconvenienced, but the photographer is not kept waiting. Mr. Van der Weyde always employs a loud-ticking metronome in the studio; as his source of light is pretty constant, if he accurately regulates the exposure, he is sure of securing negatives of equal density.

We mention the studio, but there are no studios in the ordinary sense of the term; the portraits are taken in two ordinary rooms, thickly carpeted and warmly famished, and presenting little difference from sitting or drawing-room. The one is for

groups, the other for single pictures; but, beyond the fact that in the former the reflector is rather bigger, the rooms are much alike. The dressing-rooms are well appointed, and in one of them was a large so-called Japanese mirror, a mirror such as many of our readers have seen, with folding wings, which, when opened at right angles to the front mirror, permit the fair observer to see even the back of her head, if she likes. A looking-glass like this is a more handsome piece of dressing-room furniture even than a cheval glass.

Mr. Van der Weyde charges for sittings, and not for portraits. A sitting for the promenade portrait, including eight copies, is charged three guineas; for "cabinet", including twelve copies, two guineas; or, if large heads are desired, then a guinea more is the fee. Cartes are one guinea a dozen.

The Platinotype Company at Bromley End

A bad negative, or an indifferent one, is best printed in silver; since you can see better what you are doing, you can control and dodge the better. For this reason, silver is, and will ever remain, a favourite process; but given a good negative, then platinotype may be used with advantage in a great many respects. It is true, that if you compare two prints from a fine negative, the one in platinum and the other in silver, the former, as a result, is still behind the latter, in the opinion of some photographers; but then comes in the balance of advantages. Although, as a photographic result, the silver print is to be preferred, the delicate warm grey tone of the platinum impression goes for much with a large number of people, and with painters and artists in particular, who hold it in high favour by reason of its fine engraving-like aspect. Moreover, as much by reason of its tone as on account of the unglazed surface of the print, the platinotype is thoroughly well adapted for artistic colouring.

But the principal advantage of platinotype is its permanence. Mr. Spiller has made a searching investigation of the matter, and his opinion is that the print will last as long as the paper. His plan of testing the prints he thus describes:

"Some of the prints were cut into sections and separately treated, so that the portions could afterwards be patched together again for comparison, when any loss of vigour or alteration of tone would become at once apparent.

"In this way I have tried the action of all the common acids, using these of such degrees of strength as seemed fair to the paper basis of the photographs. Thus, the nitric acid was diluted with an equal bulk of water, and sulphuric acid with three measures of water; but hydrochloric acid, having itself so little action upon paper, permitted of its being employed in the concentrated form. After an hour's immersion not one of these acids exerted the slightest action upon the platinum prints, nor did weak caustic soda, sulphurous acid, hyposulphite of soda, strong ammonia, or cyanide of potassium. The last-named reagent draws a sharp line between a platinum print and an ordinary gold-toned photograph, showing a clear distinction in favour of platinum black as against reduced gold, and negativing a direct assertion on this head by Dr. Van Monckhoven.

"With regard to chlorine, I found, much to my surprise, that a dip suspended within the neck of a flask from which chlorine gas was freely

disengaged suffered no harm; nor even in another trial when, by accident, the print fell into the acid liquid from which the chlorine was being evolved. Further, I am prepared to say that nascent chlorine does not affect the platinotypes unless the conditions are very severe, or such as to bring about an actual disintegration of the paper, as by an attack of warm aqua-regia."

But we must proceed to describe the process. Mr. Berkeley, who is one of the directors of the company, has some prints at hand that have just come from the frames, and these we examine in a subdued white light. "You know the process perfectly well, of course," says Mr. Berkeley. "Of course, of course," is our reply, and then we hesitatingly add in effect, after the manner of the Bourgeois Gentilhomme, "*mais faites comme si je ne le savais pas.*"

Mr. Berkeley is good enough to accede to our wish. "This, you see, is a roll of paper as we receive it," he says. Since it is a roll some five feet broad and a yard or two thick, there is no difficulty about seeing it, and we at once say so. "Only Saxe paper is employed, and this comes direct from Steinbach," and then Mr. Berkeley proceeds to say how it is prepared for platinotype purposes.

After a preliminary sizing, a coating of ferric

oxalate and platinous chloride is applied to the surface of the paper by means of a brush or pad, the work being done by girls, who are more light-handed than men. The platinum salt employed is that most easily reduced, and the paper is now sensitive to light and fit for issue. But platinotype has one arch-enemy, and that is damp. If you will only keep the paper dry, and all things that come in contact with it, your printing will be a success; but not otherwise. There is little difficulty about doing this, if you will follow the instructions of the Company; a tube or cylinder of tin is a handy utensil for storing paper or prints, the cylinder having at one end a receptacle for chloride of calcium, while as to keeping the paper dry in the printing frame, this is done by the simple precaution of putting a soft rubber pad or sheet over negative and paper.

The sensitiveness of platinotype paper is calculated to be about three times that of chloride of silver paper, but you cannot watch the progress of printing quite so well. The image is very faint, and it is not until the printer has had a little experience that he can judge accurately. The difficulty is one, however, easily surmounted, and, moreover, when it comes to the development of the print, you have the means

at hand to correct over- and under-exposure.

To development Mr. Berkeley now proceeds: A solution of oxalate of potash is heated in a flat dish to 170° or 180°F. If the prints are underexposed (the first print of the batch is a good tell-tale), then the temperature is raised; if over-printed, the developer is used less warm. Mr. Hollyer – one of the masters of platinotype printing – sometimes employs the bath only tepid, taking half a minute to develop a print. But, as a rule, the picture is developed instantly. No sooner have you placed the phantom brown image, face downwards, upon the warm solution than a bright vigorous picture starts into view – a dark grey print, forcible and strong, and yet possessed of that softness and delicacy which make platinotype so beloved by artists.

There is no toning, fixing, or even washing in the ordinary sense of the term. A water bath acidulated with a little hydrochloric acid receives the print, which, after a minute or two, is lifted into a second, and, maybe, a third similar bath. The object is to discharge all the iron salt remaining in the paper, and as soon as the baths have no longer a yellow tint, the washing may be discontinued.

Of what is the finished image composed it may be asked. Pure platinum, in the form that

is known as spongy platinum, or, rather, platinum black; in a word, the finest state of division in which that metal occurs. Metallic platinum, as everybody knows, is one of the most stable of substances, and, therefore, there is little fear of any change taking place on account of contact with chemical substances that may come near the film. That is to say, the platinum is not likely to change; but since platinum black is known to chemists as possessing strong catalytic action (the power to induce decomposition in another body without itself undergoing perceptible alteration), any substance in contact with it might not share the same immunity. Stephenson's well-known rejoinder to the question what would happen if a cow got upon his new railway, "So much the worse for the coo," might well be paraphrased here, for, apparently, in the case of any chemical body coming near a platinum print, the resulting danger would be only to the body in question. For all this, however, no pigment has ever been found to change on application to a platinotype.

The developing liquid – oxalate of potash solution – is employed over and over again, and must not be thrown away, since it contains after use a good deal of platinum that may be recovered in the

form of residue as easily as silver is from washings in the ordinary printing process. In the same way, trimmings and cuttings of the paper are valuable, and should not be thrown away. The prepared paper has a yellowish tint, and for this reason the laboratory or printing-room should not be illuminated by yellow glass; a feeble white light is far preferable.

As most of our readers know very well, vignetting and fancy printing is as easily conducted with platinotype as with the chloride of silver process, the results, in every case, possessing the cold grey tone inseparable to platinum. This tone, however, much as the absence of much warmth may be regretted, is at a premium with book-publishers, by reason of its harmony with letter-press and engravings. Silver prints never harmonise well with type, but platinotype does so very perfectly.

Mr. Berkeley was good enough to show us some examples of platinotype enlarging, sent over from New York by Mr. Willis, to whom we all know the elaboration of the process is due; these enlargements were secured from small negatives by the aid of electric light, and were exceedingly satisfactory, both in respect to vigour and detail.

Dr Huggins
at Upper Tulse Hill

"Here are my star photographs," said Dr. Huggins.
A small drawer is before us filled with neat lit-
tle leather boxes, that might be jewel cases, only
that their contents are more precious than jew-
els. For truly no labourer in the diamond fields
ever worked harder than Dr. Huggins has done
to secure these tiny gems. Here is a tray of them!
Each represents a glinting star from our lustrous
firmament. This one is Sirius, or the Dog Star;
this is Vega; this, one of the glittering constella-
tion known as the Great Bear; another is Arcturus;
yet another Capella; and this last, the yellow star
Aldebaran. Were they but rubies and sapphires, a
lucky search would have secured them in a month;
as it is, they represent the labours of a lifetime.

They are minute photographic negatives, as we
see clearly enough now we are permitted to take
one in our bands and examine it under a magnifier.
The image is half an inch long and about an eighth
of an inch broad, a little white band with zebra
stripes – or more, perhaps, like a bit of bamboo
straw with well-marked joints. The stripes are
not all of the same thickness, nor are they always
at equal distances, and it is to this circumstance
particularly that our host calls attention, for on the
presence or absence of these lines that the whole

teaching of Dr. Huggins' wonderful discoveries in connection with the star world depends.

But we must go back a little to explain Dr. Huggins' research clearly. For instance, they teach us, as we shall presently see, how it is possible to classify the stars; how some are very much like our sun – which is simply a star, and nothing else, and only appears larger because it is not so many millions of miles off, as the rest of them – and how some are glowing masses of matter only just beginning to burn, while others have been alight so long that they are nearly burnt out. These old, worn-out stars – or suns, if you like to call them so – will in all probability soon become but a mass of cinder or pumice-stone, such as our moon now is, which, as everybody knows, gives forth no light itself, and only shines when it reflects back the sunlight thrown upon it.

The pictures before us are not simply photographs of the stars, but photographs of the spectra of the stars. And, here, please, one word before embarking on our explanation. Lest the reader take fright at the word spectrum, or spectra, we want to say at the outset that we are not going to use any scientific terms whatever, or allude to any abstruse matters. We are going to give as unscientific an

account of Dr. Huggins' investigation as we possibly can; that is our only object, and we shall be but too pleased if we err on the side of puerility.

We say Dr. Huggins photographs the spectrum of a star, and not the star itself, and this is easily explained. Everybody who has entered a room in which a chandelier with glass drops happens to be, or lustres on the mantelpiece, knows very well that the colours of the rainbow frequently hover about them. The reason of this, too, most people know. A ray of sunlight, or daylight, however white and shining it appears under ordinary circumstances, is made up of a bundle or faggot of coloured rays, and the coloured rays are seen whenever the faggot gets dispersed. Many things will cause the dispersion of light, and turn a white ray into a broad coloured band, or ribbon of red, yellow, blue, and violet. Out of doors the rain often does it for us, and then we get the rainbow; but indoors the dispersion of light is generally due to the triangular or prism-like drops of our chandeliers and lustres. Whenever you put a prism of glass in the path of a beam of sunlight, you get this dispersion or separation of the faggot; and this dispersion is called the spectrum. If it be a beam of sunlight that is dispersed into colours, we call the band

of colours the spectrum of the sun or solar spectrum; if we look at the light from one of the stars, putting first of all a prism in the way between our eye and the star to disperse the ray, then the colours shown we term the spectrum of a star.

"But what amount of light can possibly come from a star?" the reader will exclaim. "Surely the twinkling spots we see in the heavens are not sufficient for dispersion, and for the formation of a coloured rainbow or spectrum?" We answer, not only is the light of our stars sufficient to give a tiny rainbow – by making it go through a prism – but this tiny rainbow or star spectrum can be photographed, thanks to rapid gelatine plates, and it is just this wonderful feat which Dr. Huggins has accomplished.

Of course, in his tiny pictures, we see no colour; this has yet to come. But we see something that is more important even than colour. We have spoken of star spectra, and of the spectrum given by the sun, and we may mention that most bodies that emit rays are capable of furnishing a spectrum. A red hot poker, for instance, will give you a spectrum, and so will a glowing coal. But if you want to see the colours to perfection, as they come from the prism, you must look at them in the dark; just

as in camera work you can see best to focus when extraneous light is cut off. Thus, if you darken the room in which your prism is, and only let in a beam of sunshine through a chink in the shutter, your colours, or spectrum, or rainbow, whatever you choose to call it, will be very vivid. You see the white ray coming sharp and straight from the shutter to the prism, and then dispersed into a spectrum. The more narrow your chink or slit, the clearer will be your spectrum, and when you have narrowed the slit to something like 1/350 of an inch, you will find in the spectrum something more than a row of mere colours. You will see a lot of little upright lines, which you have not seen before; and it is these lines, particularly, their place in the spectrum, their number, and their thickness, which is of importance. They are a language, which we cannot as yet read distinctly, but which, little by little, we are beginning to understand. Already these lines in the spectrum have told us much of which before we knew nothing; what they will reveal in the future, the future alone can tell.

Dr. Huggins, then, photographs the spectrum of a star; that is, he does not present his camera directly at the heavens; before the light of the star is allowed to shine upon his sensitive

plate, it is compelled to pass through a prism to be dispersed, and it is this dispersed light – this band of colours – this spectrum – of which he gets an image. And he gets not only an image of the spectrum, or rainbow, but of the little upright lines in the spectrum, too. As we said before, his negative pictures are little-white bands with "zebra stripes", these stripes, more or less vivid, being no other than the lines in the spectrum.

Now, what do these lines mean? They have reference to certain metals or substances. Thus, if we take a spoonful of common salt – or chloride of sodium, as chemists call it – and burn it in a flame, and then examine that flame, we shall find in the spectrum that it casts an upright line of a vivid yellow. This line appears in the red part of the rainbow, or spectrum, and whenever sodium is present in a flame, no matter how minute the quantity, this line always makes its appearance, and always in precisely the same position of the spectrum. We can only argue one thing from this; that there is sodium present whenever we see the line. Hence it is called the sodium line. Mr. William Crookes, the first editor of the *Photographic News*, one day burning some sulphur, and looking at the spectrum of the flame, discovered, to his

surprise, a line he had never seen before. It was a single green line, and hence he knew there must be something present in the flame of which chemists at that moment knew nothing. He proceeded with his investigation, and, in a few days, was able to announce to the world that he had discovered, through the medium of the spectrum, an entirely new metal, to which he gave the name of Thallium.

Since, then, the lines tell us of the presence of certain bodies we have in the spectrum, we have here a very easy and simple way of finding out what is in a substance that is burning. We can tell if it contain copper, iron, sodium, &c. The lines proclaim the fact at once. It is, in a word, a most efficient and quick method of analysis, this method of spectrum analysis. A ray of sunshine, falling on a prism, and dispersing, exhibits lines that leave little doubt that in the glowing mass we call the sun there is sodium, iron, hydrogen in vast quantities, &c. Dr. Huggins, in like manner, has examined the light from various stars, and, from the lines he has obtained, he tells us how, in the bright star Sirius, there is sodium, magnesium, hydrogen, and iron, and in the yellow star Aldebaran these are to be found in conjunction with bismuth, antimony, and mercury.

Now we come to the important task which photography has fulfilled in connection with this wonderful investigation. We have hitherto spoken of lines visible to the eye. But, at one edge of the rainbow, or spectrum, in the violet and lavender regions, there are lines which are invisible to the eye, but which can, nevertheless, be photographed. Dr. Huggins, indeed, does not care to photograph more than half the spectrum; the red and yellow parts he can best examine with the eye, and therefore he confines himself to photographing the lines in the violet and lavender regions, and in the region beyond, which, curiously enough, we cannot see at all. And it is precisely these regions that appear to be most interesting so far as the stars are concerned. His little photographs show at once that there are, at any rate, three distinct classes of stars. There are those, for instance, which give twelve distinct lines, or zebra stripes. These lines are evidently due to hydrogen, and denote vast masses of this inflammable gas to be present in the stars. All white stars give these twelve lines, such as Sirius, Vega, the Great Bear, &c., and for this reason it is presumed that they are youthful stars. Next, there are stars that give lines, or spectra, so much like the lines given by our own sun, that they

are doubtless of the same age, and have been burning about as long; Capella is one of these, which, among other things, do not show the hydrogen lines so perfectly. Finally, we have old suns, like Arcturus, and the yellow star Aldebaran, which seem to be rapidly burning themselves out; the spectrum here is very different, the twelve hydrogen lines, as an instance, being reduced to six.

Dr. Huggins invites us into his observatory, and we climb the stairs in his company. We make our way through a well-appointed laboratory, then ascend into an apparatus room, full of magnificent electrical paraphernalia and optical appliances, and finally, pushing open a trap above our heads, reach the "star chamber". It is not very high up, after all, where Dr. Huggins holds communion with the stars. Yet we may here see farther into the heavens than from the loftiest spire upon earth.

In the centre is a vast telescope, some twelve feet long and twenty inches in diameter; it is inclined upwards through an orifice in the roof, the roof itself being dome-shaped, and capable of revolution, so that the whole hemisphere of the heavens may in turn be examined.

It is here that the work to which we have alluded has been performed – work which may seem simple

enough to the reader, but which has involved the exercise of patience and perseverance indescribable. Who shall tell of the countless watchings, the indomitable fortitude, the persistent activity by which the triumph has been gained ? Fortunately, our worthy host has a worthy assistant in the person of Mrs. Huggins, to whom is due, in no small measure, the success of his labours. Our readers know full well how feeble is the light of a star; and when they bear in mind that only as much of that light as can come through a slit 1/350 of an inch is permitted to act on the photographic plate, this light being not in the form of a pin's point, but spread over half an inch surface, they will understand that a long exposure is necessary. Sometimes, indeed, two hours are required to impress the image, and during the whole of this weary interval it is the duty of the doctor's chief assistant to watch that star, and see that it remains in its proper place upon the slit of the instrument. The stars, as we all know, are constantly moving – or, rather, the earth is, which is the same thing – and the consequence is that the big telescope, in which the camera and spectrum apparatus are placed, has to be kept moving, too, by clockwork, to keep up with the star. But, delicately-regulated as the clockwork is, it cannot

always be depended upon to move the telescope exactly at the same rate as the earth. For this reason it is that Mrs. Huggins duly watches to see it do its duty, the lady having appliances at hand whereby she can amend the speed, and catch the star again by going a little faster, or slower, as the case may be.

Mrs. Huggins is also an accomplished photographer, and is conversant with all the advances recently made. Indeed, it is only, as one can well understand, with the aid of very sensitive gelatine plates that some of the stars – the red ones and the yellow ones particularly – can be made to tell their interesting story. "It is all very well to speak lightly of doubling the exposure," said Dr. Huggins, "when it is a question of seconds only; but, in my case, it is a matter of hours." Dr. Huggins, in his work, soon gets to know of a plate's sensitiveness; making long exposures during the weary watches of the night is a crucial test for the sensitive film.

And now, if the reader will but listen another moment, we can, in a very few words, explain how Dr. Huggins does his photographic work. We have said that the little camera and spectrum apparatus are inside the telescope, and we have explained how it is necessary, in order to get a proper image upon the sensitive plate, that the light from the

star should shine into the apparatus through a tiny slit not more than 1/350 of an inch broad. The great thing to be accomplished, therefore, is to get the little luminary to settle exactly upon this slit, and to keep it there during the long time necessary for the exposure. It is done in this way. The telescope, which is nothing more than a hollow tube, is directed towards the heavens, and in such a way that the star shines down the tube. There are many stars, of course, but Dr. Huggins has only to do with one at a time. At the bottom of the tube or telescope is a mirror, and the consequence is that the star, looking down the tube, shines upon the mirror. The mirror, then, by careful handling, is made to reflect the particular star upon the slit of the camera apparatus, and very nicely indeed has the mirror to be adjusted to do this. But this difficult task it fulfils, nevertheless, under the skilful hands of Mrs. Huggins, and to that lady, as we have said, falls the onerous duty of continually watching to see that the tiny spot of light keeps hovering over the slit. Of course the big telescope is moving all the while, and the camera inside as well, by means of the clockwork, to which we have referred, in order to keep up with the moving star; but let the mechanism be ever so well-regulated, it requires unremitting

attention, so that, as we have said, the eye has con-
tinually to watch the position of the star upon the
apparatus the whole weary time of the exposure.

It is only on certain nights in the year that star
photography is at all possible. You must be forever
on the alert, watching your opportunity. The night
must not only be clear, but steady. After rain the
stars are sometimes very bright, and they do not
twinkle, a sure sign of atmospherical disturbance.
Here is the tiny camera fixed at the end of the
spectrum apparatus, and here the little dark slide
that receives the plate; it is half-an-inch broad and
two inches long – surely, the smallest dark slide in
the world! Autumn and spring Dr. Huggins prefers
for his photographic work, and, if possible, he
brings his labours to an end at midnight. In wintry
weather he can commence work about six; but in
the summer time has sometimes to wait till ten
before the stars are bright enough for his purpose.

Dr. Huggins, in describing his apparatus, says:
It was necessary to devise an apparatus which
should produce on the plate a well-defined spec-
trum, full of fine details, with the least possible loss
of light. As glass is but imperfectly transparent to
light beyond the visible spectrum, it was necessary
to avoid the use of this substance. The telescope was

Figure 1: Dr Huggins' apparatus.

a reflector of the Cassegrain form, having a metallic speculum eighteen inches diameter. The form of spectrum apparatus is represented in the accompanying woodcut: a is a base-plate with bevelled edges, which slides with a suitably grooved plate fixed at the end of a telescope; b is the slit, having a width of 1/350 part of an inch; c is the prism of Iceland spar, a substance very transparent to the ultra-violet rays, and possessing a power of dispersion equal to moderately dense flint. The lenses, d and e, are of quartz. The plate is placed at f, and inclined so as to bring as large a part as possible of the spectrum to focus upon it. The photographic spectra taken with this apparatus measure half an inch from g to d, and the definition is so excellent, that seven lines

Figure 2: Dr Huggins' telescope.

may be seen between H and K in the solar spectrum.

The difficulty arising from the star's apparent motion required a special arrangement to enable the star's image to be brought upon and kept accurately within the very narrow chink, the 1/350 of an inch wide, through which the light must pass.

In addition to a massive equatorial mounting, and a driving dock of great excellence, due to the inventive skill of Mr. Howard Grubb, the arrangement shown in Figure 2 was adopted.

Figure 2 shows parts of the telescope. The spectrum apparatus (a) is fixed so that the slit may be exactly at the principal focus of the mirror b. Over the slit is placed a polished

silver plate, c, with an opening corresponding to the slit. By means of a small mirror, d, artificial yellow light is thrown upon this plate.

Behind the hole in the centre of the speculum is placed a small Galilean telescope or opera-glass. If the telescope is directed to a star, and the observer looks into this small telescope, he sees the silver plate and the slit within the opening by means of the artificial light. He sees also upon the plate the image of the star as a bright point. It is then within his power to bring this bright point exactly upon any desired part of the slit, and by continuously watching it during the whole time of photographic exposure, which may be an hour or more, to correct instantly, by hand, any small irregularities of the motion of the telescope.

It was necessary, further, to have the means of being able, from comparison with a known spectrum, to determine the wave lengths of the lines in the spectra of the stars. For this purpose the slit was provided with two shutters, g and h (Figure 1). During the exposure the shutter g only was open; when the photograph had been taken this shutter was closed, and the second shutter, h, withdrawn: through this half of the slit a second spectrum was taken upon the same plate. This

might be the sun's light reflected from the moon, or the spectrum of a known star, or a terrestrial spectrum, or direct sunlight on the following day.

The Woodbury Permanent
Printing Company
at Kent Gardens, Ealing

In a remote comer of Ealing, where the suburban villas come to an end, and the meadowland slopes away to the green hills about Harrow and Pinner, are to be found the works of the Woodbury Permanent Printing Company. The Company has evidently a notion of taking care of itself, for at Brompton, we remember, where it was last located, the neighbourhood was an exceedingly agreeable one, and there are certainly few working establishments in and about London which can boast so fine a site as Kent Gardens, Ealing. The building is nothing less than one of the fine villas that are here to be seen in goodly number, or rather, we believe, an hotel, it is so spacious; the rooms are light, airy, and lofty, and the grounds amply suffice for the outhouses – printing sheds, studios, developing rooms, &c. – which are necessary to the carrying on of the multifarious duties with which the Company occupies itself.

The Company produces its own carbon tissue, for, as our readers are aware, it has acquired for some years past a high reputation for enlargements printed in permanent pigments, and possesses all the necessary facilities for printing and developing; but, as a matter of course, it is the photo-relief or Woodbury process that constitutes the chief

feature of the Kent Gardens establishment. The Company has it all its own way when it comes to a question of rapid printing from portrait negatives, and, what between electioneering orders and orders connected with royal marriages, there is plenty to do. Election agents are very much alive to the publicity which photography is capable of giving to the features of the respective candidates, and orders are sometimes given for as many portraits of a would-be member as there are voters on the election roll. Again, the daughter of King Rumpeltiltskin is a favourite just now, the Princess Badoura, for she is shortly to be married, and Continental dealers are clamouring for her portrait. Comes an agent across the seas with a couple of negatives of the fair Princess; he will not leave them they are too precious – but waits uncomfortably for a few hours at Ealing, while the necessary gelatine moulds are made for printing off the pictures mechanically. Then he travels back again post-haste to continue solar printing, which has been momentarily interrupted, leaving behind him instructions to despatch 50,000 copies of the fair Princess as soon as Ealing has stamped them off.

Our readers are well acquainted with the Woodbury process, we know, but we shall nevertheless

take the liberty of briefly describing it once more as it stands in its present state of perfection. The first room is where the sensitive film is kept. It is in thin transparent sheets, and consists of gelatine with a backing of collodion treated with bichromate solution; it very much resembles the gelatine employed for cracker bonbons, only it is tougher and a little stouter. After sensitizing, it is put into a chloride of calcium box to dry, the operation being there very steadily and thoroughly carried out. The sensitive gelatine film is put under a negative in an ordinary printing-frame, and printed in the sun. They used, at Brompton, to put the printing-frames at the bottom of a box, to ensure the rays coming straight down upon the film; but this they find is not necessary if the frames are made to face in the direction of the sun. But direct rays are indispensable to the production of a good photo-relief. The gelatine film, by printing under a negative, becomes insoluble in parts (where the light has got at it), and the consequence is, that when immersed in warm water, only a portion of the film washes away, leaving an image of the negative in relief. The washing takes place very gradually, the film being placed on end, and the water passing through. The shadows in the negative being represented by

transparent patches of glass, the light has worked through here, and the result is that the gelatine film is, after washing, all over prominences, these prominences being the shadows; and they are more or less in relief according as the shadows were deep or otherwise, or according, as we have said before, as the glass negative was more or less transparent. These gelatine impressions are permitted to dry upon patent plate glass so that they may be perfectly flat, and are further toughened with alum. Stripped from the glass when dry, we have a perfect mould, in which the shadows are represented by prominences, and the lights by hollows.

Now comes the production of the metal plate, which is taken from this gelatine mould. There are two hydraulic presses in this room for pressing the gelatine mould against a sheet of lead; one of these presses is capable of exerting a pressure of 150 tons, and the other, which is employed for pictures up to 14 inches by 10, is equal to giving a squeeze of 500 tons. It is the necessity for having the presses which evidently stands in the way of Woodbury-type becoming vulgarised; that is to say, photo-relief printing is of itself such an elaborate industry, and requires such expensive apparatus, and withal the employment of so many skilled hands

in one department and another, that unless a photographer sees his way clear to issue hundreds of thousands of prints, it would never be worth his while to take up with the hydraulic process, although, it is true, Mr. Woodbury's new Stanno-type process bids fair to bring photo-relief print-ing within the means of the every-day portraitist.

Pure lead is employed for securing the coun-ter-mould of the gelatine film, the lead being rolled into plates. A steel plate serves to rest the gelatine mould upon, and this steel plate forms, as it were, the bottom of a tray, the sides of the tray being sharp knife edges. The reason of this tray-like formation is soon evident. The gelatine mould, as we say, is put upon the steel bottom of the tray, and then a sheet of lead, larger than the tray, is put upon it. When subjected to pres-sure in this way, the knife edges cut the lead, and the latter thus accurately and entirely fills up the tray. The gelatine film cannot escape the pressure, because of the steel plate below, and the conse-quence is that the lead is pressed into every detail of the gelatine, and these details cannot spread, because the tray is completely full of metal. The consequence is, that the comparatively frail gela-tine impresses the metal plate with its likeness.

The pressure is so evenly and skilfully managed, that they say a fern leaf can be put in the tray and pressed; and the fern leaf, soft and yielding as one might suppose, is still capable under the circumstances of impressing its form on the metal.

We have in the lead plate an engraving in which the shadows are now represented as deep hollows, and the highlights by prominences; indeed, the deeper the shadow in the original photograph, the deeper are the cavities. We now proceed to another room to see the process of printing from these metal plates. It is a large apartment with eight circular tables. There is a printer at each table; the table revolves on a pivot, so that he can bring under his hand, one after another, a series of printing presses, of which there are seven to each table, fixed round the margin. The process of printing consists in the fact that you employ a dark transparent ink, and the thicker the layer of this ink upon paper, the blacker it appears. The printer opens one of the presses, and you see, face upwards, the metal plate; he pours a little pool of the warm gelatinous ink upon the plate, claps a sheet of white paper on the pool, and then, with a turn of the handle, makes the paper press down upon the plate. The result is that the superfluous ink is squeezed out,

and when you open the press again presently, there is an image made up of ink of different thicknesses. The hollows in the plates have permitted a good deal of ink to remain, thus representing the shadows of the picture, while in the lights nearly all the ink has been pressed out, and in these portions the paper is white – or almost white.

As we have said, each printer stands before a round table that revolves. He has seven presses to attend to, and inks them one after another; a minute, or rather more, is consumed at each revolution of the table, so that the gelatinous ink of each picture has this time to set. They are printing a portrait of Miss Genevieve Ward at this table, as she appears in *Forget-me-Not*, at the Prince of Wales's; it is to illustrate a theatrical journal. The printing goes on very fast; a wine bottle, kept warm in a water-bath close by, holds the ink, and from this it is poured upon the shining metal. There is a dirty pool of liquid, and a white sheet of paper clapped upon it; a turn of the press, and the moment afterwards the pool and the paper are converted into four Miss Genevieve Wards, all looking as stern as stern can be, but as fresh and perfect as a clean silver print. The inking goes on, the table revolves, and the Miss Genevieve Wards accumulate, until

a boy carries them off to a canvas tray to dry, of which there is a perfect stack in the department; 30,000 cartes can be here printed in a day.

Only the purest pigment obtainable – Indian ink – can be employed in the printing of Woodburytypes, for accidental particles of pigment, however small, would ruin the pictures if they appeared in any of the highlights. The process, so far, looks simple enough, but in practice there are many difficulties to contend against. The matter of securing perfectly good prints depends upon the printing surfaces being perfectly flat. Any unevenness of the paper is enough to spoil the picture, for as the printing is simply the accurately pressing out of superfluous ink between paper and plate, if these are not both perfectly level, one side of the print will have more ink than the other, and hence the picture will be dark on one side and light on the other. Great care is, therefore, taken to flatten the paper used in printing. It is pressed between steel plates, and, moreover, varnished and gelatined to prevent the ink subsequently being pressed into the pores of the paper, for the Woodbury print, to be successful, must be a true surface print.

In other rooms, the drying, aluming – for the gelatinous picture requires to be tanned to render

it permanent – sorting, flattening, and mounting take place. The Woodbury Company gives employment to something like sixty hands, and this number will soon be further increased, for the managing director (Mr. Whitfield) contemplates extending his carbon tissue manufacture, and having an electric light, with suitable engine, on the premises, for helping in his work. The Company appear to do anything and everything in connection with photographic printing. From Mr. Whitfield's well-known work, *Men of Mark*, down to all sorts of advertisements and show-cards, executed in thousands, for wholesale houses, the Kent Gardens Establishment occupies itself. Here are pictures of rifles, fowling pieces, vases, shirt-fronts, fenders, fire-irons, neck-ties, pianos, &c. – photographs produced by the thousand. We peep into the glass-house for a moment, and cannot repress a momentary shudder at the uncanny appearance that meets the eye. First of all, it looked like a group of personages perfectly immovable; then it resolved itself into so many heads, hanging lifeless, a sort of Blue Beard's chamber; and it is only on a second glance that we perceive there is but a collection of head-dresses, with no heads in them at all. Our guide

evidently notices our scared look, for he says: "Oh! that's nothing; we had a hearse here yesterday."

The Woodbury Company are famous, as everybody knows, for their transparencies for the lantern. Photographers frequently send a whole series of negatives to be made into lantern slides (sufficient for an hour's lecture or entertainment), and, during the autumn and winter months, work of this kind is one of the Company's chief occupations. The transparent gelatine ink is thoroughly well adapted to the magic lantern, and permits the light to pass far more freely than it can do through the opaque particles of a silver positive. The way to make it will be found on referring to the chapter devoted to Mr. Woodbury.

A City Phototype Establishment

Our visit has to be made at twice, for the photographic operations connected with the preparation of phototype blocks cannot he undertaken in the city. But first a few words by way of preface. The word phototype is so universally applied to all sorts of photo-mechanical printing, that it has almost ceased to have any definite meaning, and, therefore, the process we are about to describe requires a little explanation. It is the production of typographical blocks – blocks that can be worked in the ordinary printing-press along with type we refer to, and which, as we shall presently show, are produced by a combination of three arts – viz., photography, lithography, and etching. The production of these printing-blocks has of late become a busy trade, particularly in Paris, London, and New York. We mention Paris first, because it seems to have been the cradle of the art, and the employees in London are for the most part Frenchmen. We can get plenty of good photographers and lithographers in this country, it appears; but those who understand etching are few and far between. If you can call to your assistance a skilled photographer, a skilled lithographer, and a skilled etcher, then there is little difficulty in the production of typographical blocks by the aid of photography;

but it is only in the presence of these three that success can be hoped for. The difficulties in the way of producing good work are so many that it requires the most practised in each craft to contend with them; and let a man be ever so ready in understanding the three processes involved, if he has not served an apprenticeship to them all (and this is very unlikely), he will not succeed unaided.

The *raison d'être* of these phototype establishments is not far to seek. Our cheap illustrated newspapers cannot pay for wood blocks – at any rate, for all their pictures – and a less expensive substitute is imperative. Photography stands ready to lend a hand in the dilemma. Any picture that appears in the foreign illustrated journals of sufficient interest is made to do duty again over here. The picture is sent to a city phototype establishment, and, in a couple of days, a suitable printing-block is returned. It does not matter what the size of the original picture may be, or what is the size of the block desired; the camera is ready to bring about any modifications of this kind that may be requisite, and the work is done – thanks to considerable competition – at a very low rate; the charge is but threepence halfpenny to five-pence per square inch, so that a

zinc printing-block, measuring four inches each way, is produced for less than eight shillings.

The "studio" we visit – if an open, glass-roofed shed can be dignified by the name – is the most simple of its kind within our knowledge. The photographic arrangements, too, are of a most primitive description. There is a solid square table in the middle of the apartment, measuring about four feet, and the camera, with a long base-board, is pivoted on it. The base-board, if it may be so termed, is continued in front of the camera, and ends in an upright, against which the picture to be copied is placed. It is rare that any large work has to be copied, and rare, too, that the picture has to be reproduced the same size as the original. The camera is, indeed, somewhat small for the purpose, capable of taking nothing larger than a twelve-inch plate. "But we never have an order for any very big work of this kind," says our informant.

The camera and base-board is so loosely pivoted, that it can not only be revolved with the greatest ease to suit the lighting, but either end – camera end, or the end at which the upright and picture are – may be heightened or lowered, which is done simply by wedging a block of wood underneath, much as if it were a see-saw. A

rectilinear lens, of twenty-six inches equivalent focus, is employed for the work, and the negatives present no point of difference from ordinary photo-lithographic plates. Transparent lines upon an opaque ground is, of course, the result aimed at, and this is produced by the ordinary bichloride of mercury intensifier, although, to our thinking, the Eder and Toth lead intensifier, in use at the Woolwich Photo-lithographic Establishment, gives greater opacity, and is more simple to use.

Before quitting this part of the establishment, attention was called to the "balance" arrangement for copying-cameras, in use in America, and of which we give a sketch. This arrangement would be found particularly useful for phototype work, and we may mention, by the way, that this cut was reproduced from the *Scientific American* by the phototype process we are now describing. By its means the camera and object are always kept parallel.

The lithographic and etching operations are carried on in a dark little court in the vicinity of Fleet Street, and thither we journey in company with some prints upon bichromated gelatine paper from the negatives we have seen taken. The "studio", we have said, was rough and crude enough, and the workshops here are in keeping

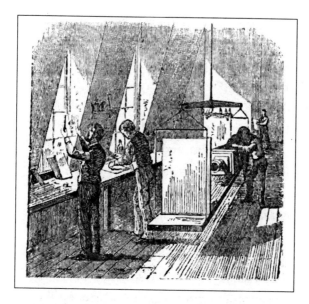

with it. The place is littered with old frames and dirty machinery; but there is plenty of work going on, nevertheless. This first division of the shop is confined to lithography; at the further end the etching process is gone through.

One of our prints is faced with ink. The lines of the drawing, which previously were of a dark brown upon the yellowish bichromate paper, appear, now the superfluous ink has been removed, of a jet black, the viscid ink standing up in ridges. In the photo-zincographic process, as it is carried on at Southampton and elsewhere, this impression

in fatty ink, or transfer, would be laid upon the zinc plate, and the latter then etched in acid. But it is different in producing a typographical block, and this is a point to which we want to direct our readers. The inked photograph is first put upon stone before it is transferred to the metal. This is an important point, and this is where the skill of the lithographer is made use of. He can produce a much better result on a lithographic stone than on a zinc plate. The former surface is so even and smooth, and, moreover, is so well in hand in the press, that if the photo-lithograph is at first deficient in some respects, it is soon improved under the hands of the lithographer. We see our print now on the stone to which it has been transferred by pressure, and the lithographer, by all the little means at his disposal – inking-rag, acid-sponge, scraper, roller, and camel-hair pencil – coaxes and amends the image to such a degree that we hardly know it again. One sees at once why a skilful lithographer, and not one who has a passing acquaintance only with the process, is necessary.

The black-lined image on stone, now well rolled up with the ink roller, and with no trace of that rottenness in the lines which was here and there visible when the picture was originally transferred,

is now ready for re-transfer to zinc. If the first re-transfer is not successful, another may be taken, and so on, once the image is on the stone; so the intermediate process, besides its utility, acts as a sort of insurance against failure. An impression is taken on a suitable piece of transfer paper, and the latter is then pressed into contact with a well-cleaned zinc surface. The image in fatty ink now rests upon the zinc plate, and this is ready for etching.

The etching process in all takes from three to eight hours. A big shallow tray or bath is filled with water acidified with nitric acid. We dip a finger into the liquid; to the taste it is acid, but not unpleasantly so. This is the first bath, and a weak one. As the etching goes on, a stronger solution is employed. During the immersion of the zinc plate the bath is kept continually rocked by a lad who sits beside it. Ten minutes or a quarter of an hour passes, and then the plate is lifted out. It is taken to a side table and then rolled up with an ink roller as if it were a lithographic stone; thence it goes upon a heated slab, which quickly dries the plate; afterwards some finely-powdered resin is sifted over it, and then the plate once more goes into the etching bath. This treatment is repeated at frequent intervals, the image being rolled up

every time it comes from the bath, and powdered resin being sifted over, sometimes when the plate is wet, sometimes after it has been dried and warmed, according as the etcher sees fit. The ink and the resin preserve that part of the zinc which they cover from the action of the acid, and as the process proceeds, and the layer of ink gets thick, the etching may go on with increased rapidity. But until the fine lines are safely etched, it is necessary to proceed with caution. The heating of the zinc-plate is for the purpose of melting the resin so that it may run down and protect the walls or ridges upon which the fine raised lines stand, and prevent any undermining by acid. Towards the end of the process, as we have said, a much stronger solution of nitric acid is employed, and the eating away of the metal goes on apace. In the end the image appears raised from the surface of the plate to the extent of a twentieth of an inch, and the finished printing-block is before us.

Millbank Prison

It is a clear morning, but a sharp east wind is blowing over the parapet from the steely Thames, as our hansom carries us quickly along the Embankment. We pass the Abbey, Old Palace Yard, the tall and majestic Victoria Tower, the magnificent stone archway known as the Peers' Entrance, and then, suddenly leaving all these fine buildings and grandeur behind us, enter the narrow street that leads to Millbank. Here we come out upon the river again, and the wind blows more chilly than ever; or is it that solemn fortress-looking building, that pile of grim brick and barred windows, that causes the shivering? There is little time for reflection, for cabby presently pulls up at a massive stone gate, beside a black doorway all studded with bars and bolts.

A big round knocker confronts us, for all the world like a heavy iron fetter, but our unsteady hand fails to raise it. "Try the bell, sir," says cabby; who coolly waits to see how we get on, and, in the hope, no doubt, that admission will be refused, speculates about the chance of a fare back. But he is doomed to disappointment. The door opens but slowly, and a little way only, it is true, but it opens sufficiently to show a warder in steel buttons and a shining chain with keys attached to

his girdle; he takes the card we thrust into the yawning crevice, and reads it. The card is satisfactory, and in another moment we are standing in the lodge, and indulging in a weak joke about the difficulty of getting into prison. But we are not there yet. Another iron gate has to be unlocked – after the first has been carefully shut – and we are then at liberty to enter confinement.

The shape of Millbank prison is that of a starfish, the centre being occupied by the governor and various officers, and the radiating wings by the prisoners. We walk, unattended, along a silent and solemn avenue, to the central offices, the dull prison walls on either side, their embrasure-looking windows more like a fortress than ever; there is no noise, and not a soul is to be seen. But we pass by a warder presently, standing in a recess so quietly that he quite startles us, and then we go by two others, one of whom has a notebook in which he makes an entry. We ask our way to the governor's offices; a gesture, rather than words, is the reply we receive.

But once in the centre of the establishment, the aspect of affairs changes. You feel that chill wind no longer; there are green leaves and ivy to gaze upon, and dilute sunshine even; you pass through busy workshops and

yards where men are at work and at exercise..

A cheerful office full of busy clerks is here, and comfortable furniture and a bright fire. There is a savoury smell of lunch about – of Irish stew, if we mistake not – which exerts quite an appetising effect. One begins to think that a prison is not such a bad place to live in, after all, for a short, a very short time, if – if – only they did not make such a bother about opening that big black door at the entrance. There is nothing unusual about anybody, now one grows accustomed to the scene. If it were not that the majority of the men were clad in a monotonous grey dress, and the minority wore a dark uniform with steel buttons and steel chains at their side, which have a metallic handcuff ring about them, one might easily mistake Millbank for some other Government establishment, say Portsmouth Dockyard or the Arsenal at Woolwich.

Armed with the governor's authority, a guide now leads the way to the photographic studio in which we are interested. He too, has a steel chain with a pass-key. Here is the glass-house – a little erection in a yard by itself. We enter. It is a model of neatness and cleanliness; in fact, we unhesitatingly say it is the brightest little studio we have seen in our experience of "At Homes".

The floor is as white from scrubbing as the deck of a man-of-war; there is not a thing out of its place; not a piece of apparatus is awry or in disorder; not a speck of dirt is visible. Strips of clean carpet are laid in the gangway, and where the sitter is posed the floor is painted black.

What about the lighting, it will be asked. The lighting, we reply, fulfils the requirements of a model studio, as we heard them recently expressed at the establishment of Messrs. Hills and Saunders. A high wall at some distance from the studio, that the sun cannot get over, so that there is little or no necessity for blinds, and the diffused light can be used as you find it. The Millbank studio is not lighted from the north, it is true; but there is plenty of illumination, and it may be employed without stint.

The photographer at Millbank is one of the steel-buttoned warders, and we congratulate him on his well-arranged studio. Here are some pictures he has just taken – half profile, bold, clear, and vigorous portraits, well lighted, and altogether unlike what prison photographs usually are. There is no 'prentice hand here, and we say so. In reply, our warder unbends his austere manner, and introduces himself as a former

acquaintance. He is no other than Corporal Laffeaty, late of the Royal Engineers, an apt pupil of Captain Abney's, and one of the clever Sappers who took part in the Transit of Venus Expedition. The mystery is solved; no wonder the Millbank portraits of late have been so good.

A sitter is departing as we arrive – a man in ordinary attire, his short, cut-away beard giving him the appearance of a foreigner. Our guide sees our look of astonishment: "He is a liberty man, and is photographed in liberty clothes; he goes out next week, and has, therefore, been permitted to grow a beard during the past three months"; and on the desk we see a printed form referring to him, to which his photograph will presently be attached. "Seven years' penal servitude, three years' police supervision", we note is upon it. His crime was forgery.

What, we ask if a man refuse to be photographed just before the expiration of his sentence? Our guide smiles: "It is a very simple matter; a man is usually set at liberty before his time, but only if he conforms to our regulations."

Our guide leaves us for awhile, and Mr. Laffeaty asks if he shall go on with his work. We reply in the affirmative, and he quits the

studio to fetch a sitter. He is not long gone, for there are plenty outside in the yard we have just crossed, men in grey, ambling round the flagged area at a rapid pace at fixed distances from one another, and reminding you vividly of a go-as-you-please race at the Agricultural Hall. He is a young man of stalwart build, the sitter, when he appears, and he is as docile as a dog. He is clean shaven, and has an ugly black L on his sleeve, which means, poor fellow, that he is a "Lifer".

There is a wooden arm-chair for posing. "Look here, I want you to sit down like this," says our friend the photographer, placing himself sideways in the settle, so as to give a half profile. The convict does as he is told, and evidently enjoys the business immensely. "Don't throw the head back quite so much; there, that will do. Now put up your hands on your breast, so." For the shrewd governor (Captain Harvey), it seems, believes that a photograph of a man's hands is as important almost as that of his face.

The warder-photographer retires to coat his plate, and we are left for a moment alone with a "Lifer". Why shouldn't he make a rush for it, fell us to the earth, and have a try for liberty? He might be a murderer; that he had committed

a terrible crime was certain from his sentence.
Keep the camera between yourself and the man,
and be ready to roar out lustily if he so much
as move a muscle, was one precaution that oc-
curred to us; or should we knock him down at
once out of hand before he began any mischief
at all? (We hear afterwards that this convict was
arraigned on a charge of murder; but a verdict of
manslaughter only was returned. He stabbed a
woman with a sharp pipe-stem, wounding her
so grievously that she died in twenty minutes.

No such precautionary measures are called
for. Indeed, it made one smile to think of such a
thing as resistance. One might, perhaps, conjure
up such thoughts as these in the presence of an
imaginary convict; but the facts here are very
commonplace. On the arm chair opposite you sits
a young man, almost a boy, with a frank, good-
humoured face – a poor fellow who is evidently
luxuriating in a delightful moment of release
from drudging work and monotonous labour. Do
what you want him to? Will he be obedient? Why,
he would stand on his head to please you and to
escape for a few minutes longer his daily toil. And
as to bravado and ruffianism; there is just the same
difference between the daring robber, and this

grey-clad, humble individual, as there is between a fighting cock with his plumes and feathers, and a plucked fowl on the poulterer's counter.

Mr. Laffeaty comes back to the docile prisoner, focuses, gives an exposure of fifteen seconds with a wet plate and No. 2B lens, and secures an admirable negative. "I have never had the least difficulty," he tells us, after he has taken back his charge, "either with the men or with the women. The men are apt to be too grave, the women are sometimes given to giggling; that is, perhaps, the only drawback I have to contend against. I never take any full-face portraits in the old style, and I think I have improved the photography itself of late. There was an article in the *Photographic News* called *At Home at Scotland Yard* some months ago, and I have taken up several of the hints given there."

Mr. Laffeaty has to work very quickly at times, and, as a consequence, develops and fixes at once, without waiting to intensify. The latter operation he does in the light, with a few drops of sulphide of potassium in water, a method which, while ready and effective, does not appear to give too much hardness.

We cross the yard once more to make a call on the governor. The grey coats are still hard at it at

their go-as-you-please-race, except a few men who have fallen out, and standing still with their faces turned to the wall like naughty boys. They have an hour's exercise a day, and some of them seem to be trying to get double the amount out of the time.

To Captain Harvey is, in a great measure, due the improvement in photography that has of late distinguished the Millbank establishment. He is good enough to show us several series of pictures. Here is Kurr, of turf swindling noto-riety. This long face belongs to Paine, convicted the other day of poisoning a woman with drink, and who, it appears, was one of the men we just now saw exercising in the yard below. Here are the two Stauntons connected with the Penge mystery, and other more or less well-known criminals. All these are "first convictions", who are confined by themselves, and bear a much better character from the warders than the "ha-bitual criminal" class, for whose special behoof photographic portraiture has been provided. It is for the passer of counterfeit coin, the burglar, and the swindler – who have little interest for the public, but a great deal for the prison and police authorities – that criminal registers are required, to aid the suppression and detection of crime.

Pentonville Penitentiary

A very mistaken notion prevails upon the subject of photographing prisoners. The popular idea is that the prisoners themselves are very unwilling to submit to the ordeal, and usually make all sorts of difficulties and disturbances, sometimes not easily overruled. Strange accounts have been published of cunning devices and ingenious tricks practised upon convicts in order to secure a photograph of their features; and we remember seeing, not long ago, a talented picture, the subject of which was an unwilling sitter maintained in position by a couple of stalwart warders, while the photographer did his worst, or rather his best. Such representations work, from the nature of things, a marked impression upon the public mind, and hence is due the impression that the photographing of prisoners is peculiarly troublesome and difficult. But it is the exceptions that the public hear about, and not the ordinary operations.

No doubt obstreperous criminals are met with, from time to time, and no doubt, too, the photographer has often his work to do over and over again; but some little experience has shown us that a more docile body of sitters than our convicts do not exist. We do not say this because, as photographers, they are easily satisfied – because

they never offer a remonstrance or suggestion – never ask to see the negative – and, above all, do not importune for a second sitting. But, so far as we have seen, they sit quieter and steadier and are more ready to fall in with the exigencies of photography, than their brethren in freedom.

Pentonville Penitentiary is the largest establishment of the kind in England. At the time of our visit there were eleven hundred prisoners within the walls, and a much larger number can find accommodation if necessary. Every man sentenced to penal servitude comes to Pentonville, and the first nine months of the period of his conviction he passes there. It is during this period that he is photographed, and the photographic records of Pentonville thus include every man in the kingdom sentenced to penal servitude. There is the same strict watch and vigilance at entrance and lodge which we described as existing at Millbank. There is the same military discipline among the warders – the same grey monotonous appearance about the prisoners. Millbank had ivy and shrubs as its principal ornament; at Pentonville, it is the green grass plots upon which the prisoners rest their eyes for relief.

So that these green spots may exist within the

tall sombre walls, grass is grown in the exercise squares, and circular paths of asphalt, some two feet wide, appear like gigantic rings one within the other. The prisoners are at exercise at this moment, and we can see them from a window in the governor's room, walking round and round the green – an outer circle and an inner circle of them, a warder on a raised platform looking on. The men are closer together than at Millbank, and step out with military precision, and for the most part with jaunty air and elastic step; some even smirk and smile as they catch sight of us at the window; swinging their arms and wagging their heads, there are not half-a-dozen who appear dull or dejected. Perhaps it is the bright sunshine that pours down upon them in their roundabout tramp. One poor fellow walks to and fro in a corner by himself; he has a wooden leg, and cannot keep up with the brisk march of his fellows.

On our way to the studio we pass through the central hall of the prison, the lofty white walls rising sixty or eighty feet on either side; tiers upon tiers of cells, having access to light iron galleries, one over the other, run the length of the hall, which is spanned at intervals by iron bridges. Warders are posted everywhere,

in vestibule, gallery, and bridge. We look into one of the cells; it measures, perhaps, 12 feet by 8 feet, and contains a hand-weaving machine, at which the prisoner works. The cell is whitewashed, is very clean, and lightened by a window some nine feet from the floor.

The governor is good enough to show us the tailoring shop, the shoemaker's shop, the laundry, the infirmary (where a dozen poor fellows are lying in bed, but as comfortable, apparently, as they would be in any hospital in London), and the kitchen, where huge boilers and stew pans are all attended by convicts. It is suet pudding day today, the only day in the week when there is no meat; but the governor says it is a favourite meal, for all that, and we are invited to taste the pudding – a pound block like a tinned loaf – which is made of whole flour, and served with the same weight of potatoes.

Universal silence reigns everywhere – in kitchen, workshop, and yard, for a prisoner is reported if he so much as opens his lips. During the whole of his sentence he is forbidden to speak to anyone but the warders, and these, as we enter, salute the governor, and immediately call out their brief report without waiting for any invitation to do so.

The photographic studio is on the second floor

of a solitary building in one of the yards, and has been built by someone possessing a knowledge of photography. The days are long since gone by when a wooden bench in front of the prison wall was the only convenience at the photographer's disposal. The glass room is, however, far from perfect, for not only is the aspect faulty, but the skirting-board rises too high to permit of a good side light. Indeed, when the prisoner sits down to be photographed, the line of light from the side is above his head. The consequence is, the top half of the studio is very light, where the sitter is not, and the lower half, where the sitter is, comparatively speaking, in shadow. But the photographer, who is at present entrusted with the work of taking portraits, is fortunately clever enough to combat with some success against the existing drawbacks, among which may also be cited apparatus that leaves something to be desired.

Six convicts file into the studio attended by a warder. They remove their caps, and sit down in a row on a form; in grey jackets and knickerbockers, with shaven faces and cropped hair, they look like big school boys. One of them takes up a narrow blackboard, some six inches wide, and proceeds to write very neatly in chalk the number

and name of the first sitter, the board being then placed above the man's head when his picture is taken. He sits on a high-backed chair, and with no head-rest remains perfectly still for the seven seconds the exposure lasts. "Look at those bottles in the corner," says the photographer, briefly, so that the man may turn his head a bit; and then the lens is uncapped. A double carte plate is used; but the men are so steady that rarely is a second negative taken; another convict takes the seat, and the narrow blackboard above the head is reversed, the back bearing the second man's name and number.

While the double plate is being developed, and another put into the slide, there is time to clean the blackboard, and put upon it two other names. There is no speaking; the convict simply pulls out of his jacket pocket a wooden tablet bearing name and number, and this is copied.

"Look at those bottles," repeats the photographer, rather sharply, to his next sitter, for the man has not heeded the first request; and put your chin down." The sitter smiles faintly, but does not obey. Ah! here is a refractory prisoner at last; we are glad of it, for we shall be able to see how matters are managed. But we arc disappointed. "He is deaf," says the warder,

who no sooner comes forward and explains to the sitter, than the latter is all obedience.

According to the regulations, every prisoner's head should be depicted an-inch-and-a-quarter in length, but this is only taken as an approximate size. The photographer does better than measure the head every time; he takes every one of the same proportion; that is to say, the distance between lens and sitter is always the same, and is never varied, a measuring rod at once regulating the interval. In this way a much better idea of the size of a man's face and features is obtained than if large heads and small were all depicted of the same dimensions.

It is necessary to produce rather hard negatives, otherwise it is almost impossible to secure contrast of any kind. The men being shaven and shorn, they present little contrast in themselves, while the dress they wear, being of a dull grey and with few folds, makes but a poor monotonous result if the negative errs on the side of softness. Under any circumstances, with the blackboard and its chalk writing above the head, the hands pressed close against the breast – for a picture of the hands is deemed as requisite, as we have said before, as one of the face, from the fact that they are so much

an indication of the man's calling – and the ugly dress, a prison photograph can never be anything but a doleful result; but it is nevertheless satisfactory to find that the photographs, as photographs, have of late years been much improved.

Besides securing records of prisoners, the practice of photographing them has one other advantage. In itself it acts as a deterrent of crime. Every criminal is aware that a picture has been taken of him, and he never knows how much this may be the means of bringing him to justice if he relapses once more into evil ways. He is apt to overestimate rather than underestimate the power of photography, and it forms, at any rate, one reason the more why he should refrain from crime hereafter when he is again a free man.

known to our readers in his pictures,
year after year, and gained medal af
need here to dwell upon the charmi
issued from his studio. The poetry c
only stirred the breast of many onloc
novelist, for in "Old Charlton" w
suggested by this very picture. "
Done" is another touch of pathos con
the same may be said of the gay
shadowed pools, the open heather, the
that Mr. Robinson has transferred to
no praise on our part, for the sim
excellence has been acknowledged by (
time.

There is, indeed, no other photogr
honoured with so many medals for
Mr. H. P. Robinson, the awards in
which it has been his good fortune to
present moment to more than half-a-
of the last Paris Exhibition—only
traiture—came to Tunbridge Wells,
and so great a show does the shining
in Mr. Robinson's atelier, that one
vocation for that of a collector of me
an artist.

Mr. Robinson's studio is one of the

H P Robinson
at Tunbridge Wells

There are photographers and photographers. Perhaps in no other profession except those of literature and art do we find so vast a gulf as between the highest and lowest in photography. Among painters there is the President of the Royal Academy, and the humble producer of signs. Among authors there is the historian who is making his name immortal, or the poet Laureate, who is the glory of his generation, and the penny-a-liner who hunts up conflagrations, and writes sensational reports upon big gooseberries. In photography we have those who, by earnest study and thorough education, have elevated their art to the level of the great professions, and the man – to be found in every town – who manufactures cartes at a few shillings per dozen. We do not wish to speak deprecatingly of the low-priced photographer; he is just as useful in his way as are the humbler workers in literature in theirs; he performs an important duty to the community by supplying cheap portraits, which, if they do not stand high as art productions, present at least recognisable likenesses. It is his object to produce portraits at a cheap rate, and he does well what he is called upon to do. But it is not of him or his class, useful as it may be, that we have to speak, but of a gentleman

who is truly one of the princes of the camera, who has helped to make photography into the great art, as, apart from science, it has now become.

The author of *Pictorial Effect in Photography* is so well-known to our readers in his pictures, which have been exhibited year after year, and gained medal after medal, that we have no need here to dwell upon the charming compositions that have issued from his studio. The poetry of *Fading Away* has not only stirred the breast of many onlookers, but has inspired the novelist, for in *Old Charlton* we may read of an incident suggested by this very picture. *When the Day's Work is Done"* is another touch of pathos conveyed by the camera, and the same may be said of the gay summer scenes, the deep shadowed pools, the open heather, the breezy yachting pictures, that Mr. Robinson has transferred to paper. These works need no praise on our part, for the simple reason that their high excellence has been acknowledged by competent judges time after time.

There is, indeed, no other photographer living who has been honoured with so many medals for pictures and portraiture as Mr. H. P. Robinson, the awards in gold, silver, and bronze, which it has been his good fortune to receive, amounting

at the present moment to more than half-a-hundred. The gold medal of the last Paris Exhibition – only one was given for portraiture – came to Tunbridge Wells, to the Great Hall Studio; and so great a show does the shining collection of awards make in Mr. Robinson's atelier, that one might almost mistake his vocation for that of a collector of medallions rather than that of an artist.

Mr. Robinson's studio is one of the very few buildings that has been built for the particular purpose they fulfil. Moreover, from the fact that it was planned and constructed after years of experience gained at Leamington and in London, we may take it that its design is well nigh perfect; but if further proof of this were wanting, it is afforded by the charming studies of children that meet one at every turn, and which, at one and the same time, proclaim the artist and the man of tact. For, in the case of these infantile portraits, the possession of art knowledge docs not, as every photographer knows, alone suffice. The taste and rare skill with which the tiny sitters are posed and draped is easily accounted for, since, beyond being a fervid disciple of the camera, Mr. Robinson has been a painter all his life, the Royal Academy having admitted his work before he had

attained his twenty-first birthday. But long study of photographic art, and of the requirements of camera and sensitive plates, has also been necessary to give our host the command he exercises over his models; and tho reason why so very few photographers succeed as Mr. Robinson succeeds, is because they either lack his knowledge, or do not take such infinite pains over the work. No doubt his studio permits him to secure more easily the effects he desires; but this, too, is the result of his labours as a photographer and artist combined.

Mr. Robinson's studio is remarkable from the fact that it does not contain one of Seavey's backgrounds. The backgrounds here are all prepared by our host by a modified Faulkner process. This clever method of Mr. Faulkner, which has now been published, was to rub wet chalks of the proper tint upon wet canvas, and afterwards soften down the effects with an ordinary clothes brush. This method of using chalks is as simple as it is effective. A skilled eye and practised hand are indispensable for applying them and wielding the brush; but any photographer who is something of an artist, will find the plan far more simple than the distemper painting. "Just took me an hour," said Mr. Robinson, pointing to a bit of sea and rock, against which

he had been posing some bare-legged youngsters; the background had evidently taken their fancy, or something else, for their portraits were as lively and merry as if the beach were before them.

Tho studio measures thirty-six feet long by some fifteen feet wide. The lighting is north, and as the wainscoting at the side runs up to a height of five feet, it is from a steep sloping glass roof that the illumination comes. There are a few curtains, and of the most simple character. Mr. Robinson never sees the sun the whole day long. Here is the camera pointed ready for a panel or promenade portrait, for Mr. Robinson has for some time past introduced this style of picture. "What lens are you using?" we ask. "Dallmeyer's 2A portrait," is the reply; and then, in his bluff characteristic manner, our host adds, "not that I think it's the best; but I've got it."

Mr. Robinson thinks there is a great future for tho panel portrait. Already he has albums for them. "I always insist upon angular openings," says Mr. Robinson, in reference to these albums, "and I have great difficulty in getting them." The panel portrait permits the photographer to exercise taste and skill in arranging drapery, and ladies' dresses lend themselves particularly well to the style.

A series of theatrical scenes which Mr. Robinson has just executed were exceedingly good. You saw the whole breadth of the stage, which was bordered in excellent taste with ferns and flowers, out of which grew the footlights. The pictures presented certain episodes in play and farce, and the action and expression of the players were capital. Here is a party of six at one of those scrambling untidy dinners, inherent to the "screaming farce"; here a drawing-room, with two ladies *tête-a-tête*; here a verandah looking on the briny ocean, with a lady evidently in hysterics, and a nervous gentleman at his wits' end to soothe her. What Mr. Robinson does, he certainly does well. The series, which numbers upwards of a score, were secured upon gelatine plates, but Mr. Robinson gives all the credit of their success to an able stage manager. Be this as it may, they are certainly the funniest, as they are the most perfect, theatrical representations we have seen reproduced by photography.

We must not forget to say a word upon the subject of carbons on opal. Nor must we omit to mention the beautiful photographic enamels for which the Great Hall Studio has been famous for some years past. We see that the prices asked for enamels vary from fifteen shillings to three guineas.

The whole of Mr. Robinson's establishment, so far as the public is concerned, is on the ground floor. The reception room opens into a small gallery, fresh and green with ferns, out of which lead the dressing rooms, while further on is the studio. Children's portraits, as we have re-marked, is what Mr. Robinson delights in, and everywhere these laugh at you from the walls, or coyly peep from the comers. As we gave a last look round at these happy faces, we could not help thinking what a world of good the misanthrope would derive from a contemplation of them all.

A good test of the quality of a man's produc-tions (on the principle that a thing is worth what it will fetch) is the price he gets for them. Mr. Robinson continues to maintain respectable and "professional" charges, notwithstanding what many people would consider severe competition, for there is a host of photographers in Tunbridge Wells, and of all degrees. But cheap photography does not really injure the heads of the profession; the public have become appreciative, and know that good work can only be got for a good equiva-lent in love or money. At the same time there is this difference between a true artist, like Mr. Robinson, and the ordinary commercial photographer – the

latter must make a profit on everything, the former spares no trouble or expense to get the best results. He says it pays in the end, and we believe him.

Jabez Hughes
at Regina House, Ryde

The "regal establishment" of Mr. Hughes, its square white-tower rising above the green trees of Ryde, is not unknown to some of our readers. The prominent site and elegant construction – a pile of Portland stone and pale brickwork – standing, as it were, on a pedestal in the middle of a bright little town, tell much for the position and emoluments of photography nowadays; and approaching from the pier, one hardly knows which to admire more, the straight lofty fabric, or the idea of choosing such a beautiful spot as Ryde for its construction. The studio is built at the top of the green fringed hill upon which the town stands, and in consequence Mr. Jabez Hughes enjoys the unalloyed satisfaction that his light cannot be interfered with.

There is surely no credit in making pictures in such a pretty spot, and we tell Mr. Hughes so. Look at those garden-bordered quays, and the sunlit waves dotted with yacht-sails that drive like snow-flakes over the blue water; see the delicate rigging of that big ironclad, the *Hercules* running down the Solent on her way to Portland to join the Channel Fleet, and far-off Osborne Point, covered with yellow-green foliage that seems to dip down to the water's edge. From here you can just see the twin towers of Osborne House rising above the

woodland slope. Now turn round and look across over the strait to Portsmouth town, that lies lit up in the sunshine yonder, between the low grim batteries by the harbour; and look, too, at the brown hills beyond, with great niches of white where the chalk quarries are. Glance your eye right and left at the azure sea, and the tiny black forts jutting out of the water like "beauty spots" upon the face of a blue-eyed belle. The Queen's photographer cannot help making beautiful pictures under such influences, we say, though 'tis true we once did hear of another reason why good photographs are taken at Ryde; it was given us by a mutual friend – no other than Mr. Toole, the comedian – and he told us it was because they got *Hughes* to it.

We walk up the street to the studio in company with our host, and enter the handsome reception room. Here is something of which the owner of Regina House may feel even more proud than of anything we have yet noticed. Every carte and cabinet picture is printed in carbon. Permanent pigments have ousted silver ones in Mr. Hughes' establishment, and the countless pictures in the showcases are all of them carbon prints. We believe Mr. Hughes is alone in being able to make the proud statement

that here appears: "Every portrait is produced in permanent photography, and will never fade."

Mr. Hughes prints by a chromotype process of his own – if chromotype it can be called, when the prints are produced unglazed, and without a margin. In other words, the negative is not reversed, but printed upon carbon tissue, which is developed on collodionised glass. The opal plate is simply rubbed with French chalk before the collodion is applied, and then there is no difficulty about separating the latter when it comes to the transfer process. In the end, the glaze upon the surface is removed with moisture, and in this way carbon prints are secured quite equal, apparently, to those by the single transfer method.

"I have said I always employ permanent pigments in general work," said Mr. Hughes; "but that is not strictly true. I do print from my negatives with the fleeting silver process, but only the unfixed proofs supplied for approval. I may say, therefore, that I utilize in their proper sphere the fading as well as the permanent process." Mr. Hughes turns this preliminary printing in silver to further account, for it affords him a valuable criterion of the density of his negatives. He employs Durand's paper, which is very uniformly

sensitive, and he knows that his carbon tissue will require just one-third the amount of printing that is necessary for albumenized paper. While on the subject of printing, Mr. Hughes also said a good word for platinotype, which he employs for special work, the results of which he likened in character to prints upon fine salted paper.

"As to reticulation?" we asked. Mr. Hughes would admit that he was sometimes troubled with this defect, but not frequently. There were two kinds, he said; one of a mechanical nature, which arose possibly from a tenderness of the gelatine, and which could, with care, be kept under control, the use of spirit being a very general remedy; the other was due to decomposition, and to cure that was impossible. He preferred keeping his carbon tissue two or three days after sensitizing; the results were then much more uniform and certain.

We have spoken hitherto of the general work, but Mr. Hughes has also a speciality in the shape of his large collodion transfers. Indeed, at Regina House, the usual order of things is reversed. While the small work is all printed in carbon, the large is done by collodion. Mr. Hughes assured us that for the past twelve years he had taken no portrait negative bigger than a cabinet; if larger pictures

are desired, these are invariably produced by the collodion process. The upper studio at Regina House contains little else but enlarging cameras for this kind of work. There cannot be a simpler enlarging process, argued our host; the negative is simply placed in the camera, and an enlarged positive is taken, which is toned and worked up as required. In other processes you have a transparency to prepare and work up; from that you produce a negative, which must also be worked up; and, finally, when you have secured your prints, these have to be worked up into the bargain.

But we have meanwhile progressed no further than the reception room. We now pass on, glancing into the well-appointed dressing rooms on our way to the forecourt of the glass room, all of which are on the ground floor, with a garden parallel with the studio. It is delightful to linger here, especially this hot summer's day. There are ferns and fresh ivy, and a plashing little fountain among the rockwork and greenery. Some rustic garden seats are at hand, and altogether the cool grotto-like aspect of the place is exceedingly pleasant. But we cannot afford to lose time, and enter the glass room. The diagram presents a section of the rooms, and will enable us to explain the mode of lighting. The lower half of

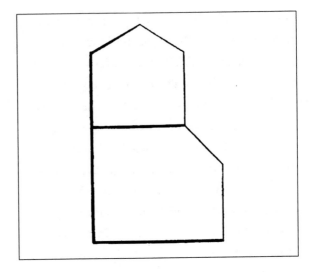

the diagram represents the end of the studio
on the ground-floor, and the upper, that of the
studio above it. The portions indicated by black
lines comprise the opaque parts, and the portions
indicated by lighter lines represent the glazed
parts. In each instance the side-lights are of clear
glass, and top-lights of fine corrugated glass, run-
ning from end to end of each room. The glass is,
in all cases, in very large panes. Those in the roof
of the lower studio are 7ft. 4in. long by 2ft. wide,
the panes in the side-light being 7ft. 4in. long by
6ft. wide. Those in the roof of the upper studio are
7ft. 2in. long by 2ft. 3in. wide; and in both rooms

there are ready facilities for opening the windows, so as to secure not only ventilation, but the effect of open air lighting uninterrupted by glass. The only blinds required are curtains running on a rod, so as to shut out portions of the side-light when necessary. It will readily be seen that, with such a flood of north light, working is rapid and the arrangement convenient. It is an apartment of handsome dimensions, measuring 35 feet by 20, and it is, moreover, some 18 feet high. Its size is the more striking from the fact that it is unencumbered with furniture. The lighting is north, and, as we see it now, the only illumination that enters is a high side light. Above is an ordinary ceiling, and no skylight at all; but inasmuch as the side wall, after rising some ten feet, slopes inwards towards the ceiling, and this slope is glazed, sufficient light comes in to give a soft, subdued illumination all over the apartment. This upper part of the side wall is covered in with dull glass of a greenish hue, known, we believe, as *Hartley's patent rolled*, and in consequence there is no definite top light, as would certainly be the case if clear glass were employed instead. The lower part of this north side of the studio is also glazed, but at present screened with thick curtains, which are withdrawn in part

after the sitter has taken his place. The light that enters from above is sufficient to illuminate the model over all; side light is then employed to give a definite effect, to point highlights, and to throw shadows. Not a ray of sunshine ever enters Mr. Hughes' studio, so admirably is it constructed, while, nevertheless, its illumination is so perfect that the most rapid exposures may be given. The full advantage of all this is realised when we remember that there is no puffing and blowing to climb to the top of the house, and no sweltering in a hot glass room when you arrive there, for Mr. Hughes' studio is in no sense a glass room; everything is cool and quiet, with a pleasant look-out on the garden through the large door-windows. The studio furniture is in every case real. Tables and chairs are of solid oak, while couch and settee, with their mouse-coloured velvet coverings, are worthy of notice, if only because of the excellent carving upon them. In a picture they appear handsome, for the simple reason that they are handsome.

We next visit the darkrooms, situated behind the studio, the distinguishing feature of which is their great height, for they, too, have an altitude of eighteen feet. Mr. Hughes has himself suffered so much from the effects of photographic vapours

and fumes, that he determined, in the construction of Regina House, to make thorough ventilation one of its chief characteristics. A system of hot-water pipes pervades the whole building, and it is only in dining and drawing-rooms that mantelpieces and chimney-places are to be found. A hundredweight and a half of coal daily suffices, by these means, to warm twenty-five rooms.

We go upstairs to the printing-rooms. The carbon tissue is sensitized here, the strength of the bichromate solution varying from three to five per cent., according to the density of the negative to print. The drying of the tissue is effected in a dark cupboard, from which the air is exhausted from below; the sheets hang upon laths radiating from a centre, which centre depends from a roasting-jack, and is thus made to revolve. In this way the surfaces of the sheets are exposed freely to the air, and are uniformly dried. Here we see the gelatine process complete – gelatine negatives and gelatine prints under manipulation.

We pass to the upper studio, where collodion transfers are prepared. There is little here to tell. The collodion enlargement is projected on to a screen, the darkroom itself forming the camera, and, after development and fixing, toned with

judgment *and* palladium. To judge of the extent of toning, the plate is turned over and examined from the back, for it is from this side, it must be borne in mind, that the print will eventually be viewed. After stripping, the film is usually covered with a bright or a matt varnish, and may then be touched little or much, as circumstances dictate.

We descend to the mounting and retouching rooms, and the negative store-room, where countless plates, each packed in a paper envelope, are ranged in rows of pigeon-holes. *Billiard-room at Osborne, Queen's sitting-room, Drawing-room,* are read upon various packages, for every envelope bears outside the name of its negative. Here are the negatives of the Princess Fredrica and her husband, who have just been photographed in bridal attire "by command of Her Majesty", and here, too, are the pictures of Lord Beaconsfield, and of his private secretary. Lord Rowton.

We may mention, in conclusion, the terms at Regina House for cabinet and carte pictures in carbon. The former are charged at the rate of a guinea and a half per dozen, and the latter at eighteen shillings. But Regina House does not make it a practice to issue a printed list of prices.

Kew Observatory

When George III was king, and the good old monarch, tired with the affairs of State, betook himself into retirement, he spent a good deal of his time at an observatory he built for himself at Richmond. It was a sort of hermitage, a white block building standing alone in the green vista of parkland and verdure, and in this quiet solitude many hours in the evening of his life were passed. Several fine telescopes were fitted up here for the old King's use, and with a few congenial companions he occupied himself in peering into the heavens and watching the movements of the planets. Some said that the King's intellect was weak, and that this last predilection of his for the moon and the stars was the symptom of a diseased brain; but there was method in his madness, if madness it was, and the scientific men of today have much to be thankful for to his Majesty, for he gave them Kew Observatory.

The telescopes and other astronomical instruments are no longer to be found at Kew, and it is now a magnetical and meteorological observatory *par excellence*. The establishment is under the charge of Mr. W. M. Whipple, and a more efficient superintendent it would be difficult to secure. Mr. Whipple's duties, as we shall presently see, are very varied, and when we add, that to a thorough

acquaintance with the matters with which he has to deal, he unites considerable tact and an amiable and courteous disposition towards the numerous scientific and general visitors who call at the Observatory, we have said enough to prove that he is essentially the right man in the right place.

The Observatory is delightfully situated. A few minutes' walk from Richmond station you pass into a large farm, and once through this farm you are in the old Deer Park. A stretch of green meadowland is before you, and more than a mile in front, with a background of verdant foliage, is the white Observatory, the clustering trees of Kew Gardens to your right, with the quaint Pagoda rising high above their branches. The silver Thames is seen here and there on the margin of the grounds, and on the left, among the yellow green boughs of oak and chestnut, is the bridge that spans the river near Richmond. Afar off is a trim lawn that has been turned into a cricket field, and tiny forms in white are rushing about in the sunshine; while close at hand, in deep contrast, is a black spreading cedar, in the shadow of which the brown cattle are lazily feeding.

In no other establishment can better proof be afforded of the aid photography lends to science.

The art is here the hand-maiden to half-a-dozen branches of science, and excellently well does it perform yeoman service. Day and night photography notes the temperature of the air, the pressure upon the barometrical column, the electric condition of the atmosphere, and the magnetical disturbances that take place in our mighty earth. A camera is ever busy watching the motion of a pencil of light which moves with every slight meteorological change, thus securing a record valuable to the world at large. Kew is in connection with seven other observatories in Great Britain, and with more than twenty situated throughout the world, and at each and every one of these stations observations go on simultaneously, which are of the utmost importance for comparison. In far-off China an observatory has been established, and Mr. Whipple showed us the first record just received from that distant station.

We will turn our attention to the thermometer first. The photographic record in this case is termed a thermogram, and here is a representation of one (Figure 1).

The upper line is the record of an ordinary thermometer, the lower of a wet bulb thermometer. The zig-zag, as it rises and falls indicates rise and

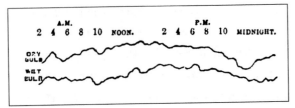

Figure 1: Thermogram.

fall of temperature, and the time of day is given by the figures above. The exact value of these zig-zags or curves, in degrees, is at once found by placing over the thermogram a glass plate upon which are engraved certain lines and cross-lines; these lines constitute the key, and show at once the value of a curve half or a quarter of an inch in height.

Now let us look at the instrument in action. We enter a quiet darkened room, in which two shaded lamps are burning. We can see but a portion of the thermometer, but it is just that portion we want to see. It is somewhat different to an ordinary thermometer. The column is of mercury, and there is a little bubble in the column which moves up and down as the temperature varies. The thermometer, therefore, presents a perfectly opaque body, except where the bubble is. Light from a lamp shines upon the instrument, and, as a necessary consequence, the light is seen coming through the bubble as it would through a window. At every

change of temperature, therefore, this little spot of light rises and falls. Now the camera comes into play. It is an ordinary lens and camera, except that, instead of a sensitized plate, there is a cylinder, round which sensitized paper is rolled. The back of the camera is opened, and we see a tiny bright spot upon the sensitized paper, the spot representing the bubble of the thermometer. There is a clockwork movement attached to the cylinder, and the sensitized paper thus gradually moves, the pencil of light making its mark the while.

At the end of twenty-four hours, or forty-eight, as the case may be, when the cylinder has made one revolution, the sensitive paper is taken out of the camera, and carried to the developing room, where a zig-zag line or curve is developed, indicative of the rise and fall of temperature during the past twenty-four hours.

The rising and falling of the barometrical column is written down by a camera in something after the same fashion, but we have to descend deep down into the basement to see this camera at work, so that the mercury column may be affected as little as possible by variation of temperature. In company with the barograph, in this cellar-like apartment, are three magnetical instruments,

with cameras attached. These record the mag-
netical disturbances of the earth. The light in all
these cases is obtained from argand gas-burn-
ers, and the moving pencil of rays is sent from
a tiny mirror poised upon the magnetic needle.
According as the magnets are pivoted, so they
tell of the different forces in action – declina-
tion-force, horizontal-force, and vertical-force.
Magnetical currents, even of a delicate nature,
passing through the earth, are not without action
upon these delicately-swung magnetic needles,
and if the needle is affected in the least degree,
the mirror in like manner moves, and thus the
pencil of light is moved also. Revolving cylinders,
covered with sensitive paper, here also record
the movements during the twenty-four hours.

Records of this nature were first made at Kew as
far back as 1858, and these were preceded by experi-
ments several years earlier, in the days of Daguerre-
otype. In 1858, too, Kew first began to take its solar
photographs, which have since become so famous.
From 1858 until 1871 a photograph of the sun was
taken almost daily, and the assistants at the estab-
lishment are said to have made no less than 5,000
measurements of sun's spots. As may be supposed,
the Kew astronomical photographers possess some

experience now in the matter, and they still incline to the use of wet plates for such work. To be of any value, a solar picture must be underexposed and underdeveloped (in ordinary photographic parlance), and, moreover, it should not have a sharp disc-like appearance; on the contrary, towards the limb the sun-picture should gradually soften. The Transit of Venus photographs did not prove so successful as they might have been, because they did not comply with these preliminary conditions.

The hours of sunshine during the day are also recorded at Kew. Sunshine, however, only writes itself down when it is strong enough to char paper with the aid of a burning-glass. Sunshine that is at all hazy, or sunshine in the early morning and towards sunset, when it has little power, is not recorded. The instrument is very simple. In order to have a burning-glass that will act all day, a crystal globe is employed, three inches in diameter. This is placed on the roof of the Observatory, and around, but not touching it, in a sort of bowl, is a blue strip of paper. This paper is in the focus of the globe, and when the sun shines a pencil of light chars the card to the extent of a pin's head. If the sun goes on shining all day, the hot ray of light travels gradually round the interior of the

bowl, charring a line upon the paper; if the sun comes out by fits and starts, the burnt line is not continuous, but appears at intervals. At the end of the day, the card strip is removed; it is divided into sections to represent hours, and it is apparent how long and when the sun shone during the day.

We have not time here to refer to the good work done by Mr. Whipple and his assistants at Kew in respect to the testing of barometers and thermometers by the standards that are kept here; but we must just say a word upon the photographic paper that is prepared at the Observatory. The process employed is a modification of the Calotype method, and very similar to that made use of at the Royal Observatory at Greenwich. The paper is of very fine structure, and transparent, so that a second sheet may be rolled upon the cylinder, and a duplicate record secured. It is treated with iodide and bromide of potassium, sensitized on a strong silver bath that contains a little acetic acid. The development is effected slowly by the aid of gallic acid, the sheet being placed upon a glass plate and the developer poured over it, sufficient of the solution being absorbed for the operation. Sometimes three hours is taken up in development. The only difficulty that occasionally bothers the observers is the tendency

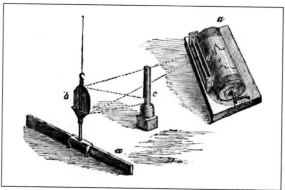

Figure 2: Photo-magnetic recording.

of the paper to blacken, arising, Mr. Whipple believes, from the ozone in the atmosphere.

The late Mr. C. Brooke, F.R.S. was the first to construct a photo-magnetic recording instrument. His principle is shown in annexed cut (Figure 2), in which *a* represents a part of a bar magnet; *b* a concave mirror, resting on a stirrup firmly attached to the suspension apparatus, the whole being supported by a single thread; *c* an ebonite cylinder wrapped round with photographic paper; *d* a plano-convex lens; *e* a lamp placed a little out of the line which joins the centres of the cylinder and magnet in operation. A pencil of light passes from *c* through a very narrow aperture, diverges and spreads over the mirror *b*, from which it is reflected, and diverges to the lens *d*, and is

condensed into a well-defined spot of light at the surface of the paper. The action of the spot upon the photographic paper is to leave a trace, which is, however, imperceptible until subsequently revealed by the application of a developing solution.

Brown, Barnes & Bell at Liverpool

There was no reason to go all the way to Liverpool to visit a studio of Messrs. Brown, Barnes, and Bell, for London contains two of their establishments, and there are a round dozen of others in the principal towns of Great Britain; but it is at Liverpool that the firm is "at home", and to Liverpool we accordingly journeyed. Even at Liverpool we did not visit the whole of the premises occupied by the firm. We were, we frankly admit, only at the principal studio in Bold Street, and at the principal printing and mounting establishment in Mount Pleasant; but it will be difficult, nevertheless, within the space of this article, to give an adequate account of what we did see of the doings of this enterprising triumvirate of photographers.

We have inspected a good many studios, both in this country and abroad, but, as a photographic establishment which does not publish work, that of Messrs. Brown, Barnes, and Bell is by far the biggest that has come under our observation. We counted a score of employees in the printing department alone, all engaged upon solar printing, and in the mounting and spotting branch the hands were more numerous still, the former work being undertaken by men and boys, and the latter by women and girls. In the toning-rooms,

an average of 2,000 impressions pass into the bath daily; in the sensitizing-room, from 130 to 150 sheets of paper are floated every day.

"We may not go in for the very highest class of work," said Mr. B., one of the members of the firm; "our motto is, *Go ahead*, and we do go ahead as much as we can. The London branches do their own printing and finishing; but Glasgow, Birmingham, Edinbro', Manchester, Leeds, Bradford, Wigan, Henley, Southport, Bootle, Nottingham, and Newcastle, all send their negatives to us at Liverpool."

In short, the firm's object is to cater for the million, and not for the few; their ambition is to do good work of a good class, and at a moderate cost. Here are the prices: Twelve cartes-de-visite, 7s. 6d., or if vignetted, then only half-a-dozen are given for this sum. Cabinets are 15s. 6d. the half-dozen, and one guinea the dozen. "Photographs to be paid for at the time of sitting", is the universal rule. On approval, the negative, together with the order, are sent to headquarters to be dealt with.

The first proof from every plate is pasted on a sheet of paper, or printed schedule, which is filled in with the necessary particulars, and the colour of this sheet, whether yellow, blue, red, orange, &c., indicates the locality from which

the photograph has been received. Obviously, it is only by adopting a most business-like system, that so vast and intricate an establishment could be organized and kept going; and when we mention that not only portraiture, but all sorts of miscellaneous work is likewise undertaken by the enterprising Liverpool firm, it must be a good system indeed to work without a hitch.

The head-quarters office, is at Bold Street. We pass by a fine collection of photographs, in which the new panel or promenade pictures are conspicuous, and walk upstairs. The firm desires that we should see something of what they propose to do in the future, before we proceed on our visiting round. *Imprimis*, there is a handsome folio volume to admire, *The Pictorial Relics of Ancient Liverpool*. Fine paper and bold type are seen in conjunction with some exquisite, rare reproductions of sketches made half-a-century ago and more, of Liverpool. The sketches – seventy-two in number – were collected from many portfolios, their owners placing the pictures freely at the disposal of the firm, who were thus enabled to produce the magnificent volume before us. "It's not bad for a provincial production," said Mr. B., in reply to our encomiums, and, indeed, Liverpool is fortunate

in possessing such "pictorial relics". When will London have such a volume, we wonder?

Here is something else equally attractive. Milled notepaper has been popular, but people are getting tired of it; so Messrs. Brown, Barnes, and Bell propose to impart to letter writing a further charm. Here are half-a-dozen designs – pieces of cardboard some twenty inches high – which may be regarded as magnified sheets of notepaper. Upon each sheet is an elegant linear design in Indian-ink; there are, perhaps, a score of parallel lines down the page, to aid in writing straight, and at the margin are scrolls, and crests, and water-lilies, &c., &c., finished also in Indian-ink. These designs will be photographed and a block prepared by the Woodburytype process, or, rather, by a modification of it, which is familiar to many of our readers, under the name of photo-filigrain. With this block notepaper will be embossed, and the result will be sheets with a delicate watermark design and a slightly embossed surface. There is this material difference, however, between the ordinary watermark and that imparted by Mr. Woodbury's ingenious process: in the former the markings are formed by lines uniformly transparent and of considerable thickness. The photo-filigrain process,

on the other hand, not only permits the formation of very fine lines, but will reproduce half-tones as well, if these were present in the original design.

Another obvious advantage is cheapness. To make a fine design for water-marking is very costly, fifty to a hundred pounds being sometimes spent upon it; to practise photo-filigrain, you may take your design whence you choose. Whatever the camera reproduces can be adopted as a design. Our host, Mr. B., indeed, hopes soon to be able to say to photographers, "Send us an impression of any portrait negative upon the sensitive tissue we forward you, between folds of yellow paper; we will then supply you with a quire or more of note-paper, in which your portrait shall be exhibited as a water-mark." The Liverpool firm, in a word, propose to make a clever use of a clever process.

We have little time to speak, as we should, of the efforts Messrs. Brown, Barnes, and Bell are making in conjunction with Mr. Woodbury to supersede engraving on wood or steel. In Paris, as our readers are aware, the firm of Goupil et Cie. have already out-distanced all others in the success that has attended their efforts in this direction, and there are now to be seen mechanical portraits that cause us to rub our eyes, and doubt

whether it is photography or a true engraving we are looking at. The Liverpool firm is a competitor in the same race, but at present their efforts are more particularly directed towards turning a draughtsman's sketch into a type-block for printing. A French publication – *La Vie Moderne* – already exists, which employs the camera to translate its sketches; but these newspaper illustrations are capable of considerable improvement. It is indispensable to have a grain throughout the picture in a process of this kind, and one of the most successful plans that has been tried in Liverpool is to make the sketch upon a paper over which a network of black lines has been traced, the veil-like markings having a close likeness to that borne by reticulated tissue. Upon this black-veiled paper an artist sketches in crayons; wherever his point touches, a black line results, covering up the network, the result being a drawing of a somewhat degraded character, since there are no highlights. To get these he employs an eraser, or the point of a knife, which scrapes away the black veil, and thus lays the white surface bare. Therefore, in the end, the picture is made up of three gradations, if we may so term them: bare white paper for the highlights, the network for the middle tints,

and black crayon lines, more or less close, for the shadows. Of this sketch a photograph is taken on the Woodbury tissue, which, by washing, is made into a mould, and from this mould a plaster cast is secured. It is then a comparatively easy matter to get a type-block from the plaster cast.

At Bold Street, there may be said to be three reception rooms, one above the other, on the ground, first, and second floor; so that, if there are many customers waiting, this circumstance is not rendered too obvious to the last comer, who might be frightened away if he saw the full extent of the queue. But the rooms are not only elegantly and comfortably fitted up; they are so full of interesting pictures, that half-an-hour is quickly spent within their walls. Collodion enlargements on opal, collodion transfers, and carbon prints are here in profusion – some perfectly untouched, others more or less highly finished in oil, and black-and-white, to suit all tastes and all purses. Here is a charming enlargement – two tiny sailor boys perched aloft on the truck of the main mast among the rigging, with a clear-lit sea behind them. In the studio presently, we see the "accessory" that has been here employed, an object of a very simple character, which is placed in front of a sea background, the seat

being some five feet from the ground, so as to give the effect of height. Not far off is another picture of interest – the portrait of a rough gold-digger in a Californian landscape. "He came to us," said Mr. B., "with a yellow, stereoscopic picture, showing the spot where he made his fortune, and the wooden shanty in which he had lived during the making of it. 'Here's my diggings, and here am I myself; now, can't you make a portrait of me, and put me alongside the old place?'" The Californian's wish was gratified, and the picture before us tells how successfully the *tour de force* was accomplished.

These are legal pictures. Here is a substantially-built house, with two tumble-down cottages beside it. The owner of the house heard that his friends next door were about to pull down the adjoining premises, and build them up again, on a finer scale; there was talk of a lofty establishment that bade fair to obscure the light of the house-owner, so the latter conceived the happy idea of having the old buildings photographed forthwith, as they stood, so that, in case of a law dispute about "ancient lights", good evidence should be forthcoming as to the actual height of the old dwellings. Another illustration. The nose of a ship has been damaged, and, while it is lying in the dry dock, a photograph

is taken to record the extent of the injury. It is the result of a collision, and there will probably be a dispute as to the amount to be made good. "This is the birthplace of Gladstone, in Rodney Street," said Mr. B. "An old lady living there objected to our taking the photograph; we told her Mr. Gladstone was public property, and we should do as we liked. However, she was perfectly satisfied in the end, when we presented her with a copy of the picture." There are, by the way, many fine pictures, on a large scale, of private residences, and we doubt whether there are many photographers who are so alive to the turning of an honest penny in this branch of business as Messrs. Brown, Barnes, and Bell.

We go across to the printing and mounting establishment, having first announced our coming through the telephone. Nearly a hundred people are here employed, and Mr. B. tells us the number of employees and families dependent on the firm are scarcely less than one thousand. Think of that, all you who despair of getting a livelihood out of photography! Here are store-rooms for incoming and outgoing packages; here is the frame-makers' department, in which frames of all sizes are turned out by the gross, the firm's business in club enlargements being especially great. Farther on are

the toning rooms; lime toning only is employed, and in washing, toning, and fixing, the utensils employed are all of slate. In Mr. B.'s opinion there is not a cheaper and better material for the purpose than enamelled slate. The slabs are screwed together, and the joints made tight with white lead. The water in the bath remains clear and cool, and a utensil, two feet square, costs but twenty shillings.

The outhouses and yard devoted to printing present a very busy scene. In the open, upright screens secure shadow; but there are conveniences for printing under any conditions. You can easily tell the dry plates from the wet when they are in the frames; the former are black, the latter white. "You don't like dry negatives, Mr. Oliver, do you?" says our host; and Mr. Oliver, who has had charge of the printing arrangements for the past fifteen years, replies most emphatically that he don't.

We go upstairs, moving from room to room. Sensitizing, mounting, touching, and painting are busily going on. From the first floor we go to the second, and from the second into the roof, where the collodion enlargements are made. There is just as much bustle up here as down below. Coating, sensitizing, and stripping are going on in a series of laboratories, and close by is the enlarging room.

An opening in the roof receives the small negative, under this is the lens, and a table below receives the sensitized collodion plate. "No sunlight is employed, but direct rays from the sky, and, under these circumstances, an enlargement is secured in ten seconds. There is no dark-slide, the room being sufficiently gloomy to prevent the film taking harm when it is carried about; the negative is adjusted and focussed, and then the sensitized opal plate is brought from the bath, and laid on the table, upon which the enlarged image falls. After an exposure often seconds, the plate is taken up and developed. A hundred collodion enlargements a day are sometimes made in these laboratories.

to be found in the establishment of M
says something for their administrative
of hands is engaged all the year round
regulated that, both summer and winte
in one department or the other.

Perhaps the best idea of the extent
gathered from the fact that 3,000 prin
number to produce, while upon the
found, at any rate in dull weather, a
The principal work is the production
Mr. W. D. Valentine being responsible
as our readers know, include the mo
have ever been taken of that delightful
Scottish scenery is here. A cluster o
strewn with brown seaweed, and beate
white foam is tritely characteristic of th
loch, with stately craft floating calmly
lighthouse of silver grey, rising from a
surrounded by turbulent waves flecl
painting; lichen-grown crags, sweet fo
gardens, bowery foliage—in a word, na
mood is here represented.

The Messrs. Valentine also enjoy
traitists, and it is, indeed, into the po
devoted to portraiture that we are fir
furnished leads to the reception room,
takes us through the dressing-rooms t
mention here that it is in the reception

James Valentine & Sons
at Dundee

The largest photographic establishment in Scotland, and one of the largest in the world – that of Messrs. James Valentine and Sons – takes very high rank indeed. Mr. James Valentine himself died two years ago, just as he had completed the reorganization of the vast undertaking which bears his name: but his sons (Mr. W. D. Valentine and Mr. George Valentine) have shown themselves in every way equal to the task of carrying out their father's designs. As many as forty employees are to be found in the establishment of Messrs. Valentine, and it says something for their administrative ability that this number of hands is engaged all the year round. The work is so well regulated that, both summer and winter, there is plenty to do, in one department or the other.

Perhaps the best idea of the extent of work done is to be gathered from the fact that 3,000 prints a day is not an unusual number to produce, while upon the printing-tables may be found, at any rate in dull weather, as many as 700 frames. The principal work is the production of views of Scotland, Mr. W. D. Valentine being responsible for the negatives, which, as our readers know, include the most delightful scenes that have ever been taken of that delightful country. Every phase of

Scottish scenery is here. A cluster of dark granite boulders, strewn with brown seaweed, and beaten by angry waves, whose white foam is tritely characteristic of their spent wrath; a placid loch, with stately craft floating calmly on its surface; a solitary lighthouse of silver grey, rising from a clump of black rocks, and surrounded by turbulent waves flecked with white – a very painting; lichen-grown crags, sweet forest glades, delicate fern gardens, bowery foliage – in a word, nature in every shape and mood is here represented.

The Messrs. Valentine also enjoy high reputation as portraitists, and it is, indeed, into the portion of the establishment devoted to portraiture that we are first led. A hall tastefully furnished leads to the reception room, whence again a corridor takes us through the dressing-rooms to the studio. We may mention here that it is in the reception-room that the only open fire in the whole establishment is found, for, following the example of Mr. Marshall Wane, of Edinburgh, Messrs. Valentine employ hot-water piping throughout. They make use of Keath's boiler and coil, which is found to be exceedingly economical, for upwards of forty rooms are heated by its means, at an expenditure of between six and seven shillings a week.

Gas cinders only are required for consumption, perhaps the most economical fuel one can use.

The studio itself, which is forty-six feet long, was most agreeably warmed (and this, too, albeit our visit was in February). Studios are apt to strike chilly in our experience, and if a sitter has to divest him or herself of any garments, a cold glass-room is not only unpleasant, but adds to the difficulties of the photographer. In Dundee, no doubt, cold is a greater enemy than in most towns; but still, the example of Messrs. Valentine is one well worth following. Moreover, the system of heating obviates many winter difficulties. "The snow never lies on the roof here," says Mr. W. D. Valentine, "for there is always warmth sufficient to melt it as it falls."

Curtains are almost unknown in Messrs. Valentine's glass room. Side light, and light from the roof, is tempered by means of upright zinc shutters on hinges. The height of the lower range of shutters is 3 feet 6 inches, and of the upper one 2 feet 6 inches, their breadth being about 20 inches, the same as the sash. They are painted on the inside (that next the glass) of a pure white and when opened more or less reflect light upon the model at the end of the studio. Our sketch (Figure 1) will give tome idea of their construction

Figure 1: Messrs. Valentine's glass room.

Not only the end of the studio but also the angle farthest from the glass is fitted up as a background. The angle indeed, forms a rustic arbour, tastefully arranged with fragments of cork bark, ivy &c., so that with but little trouble it is constituted an apt and unconventional background for groups, &c.

A change from the ordinary flat background is at times very welcome, and by simply turning the camera this is here secured.

We pass through the retouching room, noting on our way two little points. The one is a plan

of concentrating light upon negative or print; the ordinary plan, which has already been pointed out, is to have a spherical decanter of water near at hand, which condenses the light upon any spot upon which you desire to work; but Messrs. Valentine employ, instead of water, a weak solution of sulphate of copper, the greenish hue of the latter being less trying to the eyes. "It is what jewellers always use," explains Mr. Valentine. The other point is that of employing a developed gelatine plate instead of pure glass to support the negative during retouching; the brown tint of the former is also preferred, as being less injurious to the eyes.

There are no doors to the darkrooms. Mr. Valentine holds them to be not only unnecessary, but positively harmful. They give rise to dust, and they are always in the way. They are, too, easily done without. The passage leading to the dark rooms is only lighted from the top, the panes of the skylight being reddened. In these conditions of lighting from above, all that is necessary is to place inside the entrance of the dark room a broad barrier, or partition, round which you must walk to get into the room. In one of his darkrooms, by-the-way, Mr. Valentine showed us a huge pane of ruby glass, which, after but two years' exposure to

light, had lost more than half its original colour. Photographers, therefore, will do well to look after their windows occasionally; fortunately, most of them begin by working in a light that is far more subdued than is actually necessary.

But we must pass on. We go downstairs to the printing department. This occupies the whole of the basement, the principal portion being a long room, in which there are no less than twelve tables ranged side by side, each measuring about 9 by 2 feet. It is the biggest printing room we have ever seen. At each of the tables stands a girl with printing frames, and her duty is simply to open each frame, withdraw the print, provide a fresh piece of paper, and then to push the same through an open window to the printer. For, opposite each table, there is a window of this kind, opening directly into the yard, so that all the girl need do is to carry her freshly-filled frames to the side, and the printer by putting by putting his hands through, reaches them without difficulty. In the same way, the frames are afterwards returned. In all photographic establishments, the difficulty is with new hands; but the Messrs. Valentine by thus subdividing the work, get over it very well; that is to say, those inside the printing room need hare very little

experience compared with those occupied with the actual printing, who number among them the most skilled employees of the establishment.

The printing is done in the open air or under shaded glass according to the season of the year. Many of the pictures require skies printing in, and this of course necessitates double work. Mr. W. D. Valentine arranges with the head printer what sky negative shall be employed for a particular picture, and then the printing frame containing this, instead of being returned to one of the ordinary changing tables, is taken to a separate department, where the sky negative is adjusted, and a suitable mask fitted.

The sensitising of the paper takes place in a compartment at the end of the printing room. Three baths are emptied, large enough to take a whole sheet, each bath provided at the end with a glass bar or rod, over which the sheet is dragged after being lifted from the liquid. There is no draining of the sheet: the glass rod has removed the spare liquid from the surface, and immediately afterwards the paper is pressed between blotting paper. It is half dry by this time, and requires to be hung but a very short time to be completely desiccated. Nevertheless, Messrs. Valentine contemplate

drying still more quickly by means of hot water boxes, over which the paper will be stretched on net-work. The regulation time of floating the paper is two minutes; the strength of the baths, fifty-five grains of silver nitrate to one ounce of water.

It is one man's duty to fold the sheets of sensitized paper, and to cut them, a knife fixed hinge-wise to a board serving to do this very rapidly. "By this means, our prints have always clean-cut edges, a matter of much importance when it comes to toning and washing," says Mr. Valentine.

We have not time to speak of the negative rooms – all negatives in use being racked, while reserve and stock plates are packed in paper – but must pass on to the washing room. Here, raised in the centre of the long apartment, are a number of baths; there is, in fact, a double row of seven, so that two sets of assistants, facing each other, can work at the same time. The prints are first put into No. 1 bath, rinsed, and then placed in No. 2, whence they are conveyed to No. 3, and so on till they get to No. 7. Above the baths are hanging india-rubber tubes, which supply both warm and cold water; and each bath is supplied with an outlet that empties it rapidly. The water from the first four baths runs off into a residue tank

Figure 2: Section of Residue Tank

in the yard, but the other washings are thrown
away. Each print is taken separately in hand, and
handed from one assistant to another. After ton-
ing and fixing, a washing even more thorough
ensues, for after rinsing all night in tanks, in
which each print is nipped separately between
laths to prevent conglomeration, the prints are
put one by one on a glass plate, and subjected to
the action of falling water, both warm and cold.

Messrs. Valentine, have given the question
of residues careful study. The tanks are placed
in the open yard, in the full glare at daylight, for
they find that the deposition of the chloride takes
place much more rapidly out-of-doors, than in.
In summer the deposition is very rapid, while in
winter it is comparatively slow; but still there is no
danger of losing suspended particles by drawing

off liquid that has stood twenty-four hours in their tanks. Moreover, with the washing arrangement we have just described, the assistant cannot throw away valuable washings, but the liquids must of necessity ran into the tanks. The bottom of these is wedge-shaped, so that when emptied of liquid the residue cannot be carried off.

The old hyposulphite baths used for fixing prints are collected in separate tank. The most economical plan is to treat them with so-called liver of sulphur, and thus extract the precious metal in the form of sulphide. But, practically, Messrs. Valentine find it best to throw down the silver in the metallic form by means of zinc. Fragments of old zinc will do – sheeting, water-spouts, &c. – and from these the black deposit is brushed from time to time, and collected. "The silver collected from our hyposulphite washings fetched thirty pounds last year," said Mr. Valentine, in reply to our question as to whether it paid.

We are next led into the mounting room. The mountant employed is gelatine soaked in water, and then dissolved in hot spirit. But they are very particular about the brushes employed, since most of these leave "brush-markings". A brush two inches broad, of red sable, is the only

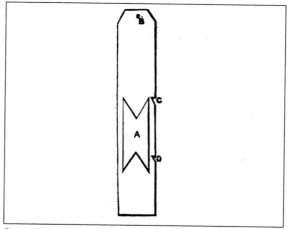

Figure 3: Shutter drop piece

instrument permitted in the establishment,
and the price of these, we were told, was no less
than fourteen shillings. The tables here are all
covered with linoleum, not only to protect them
from wet, but also because the soft character of
this material is not likely to injure any albums
or finely-bound books that come into the place.

Mr. W. D. Valentine has devised a very simple
and effective gutter constructed of thin sheet
metal. The actual drop piece is represented by
figure 3; and by making the opening A of the shape
indicated by the drawing, somewhat less exposure
is given to the centred portion of the plate than
would be the case if a plain rectangular opening

Figure 4: Mechanism for releasing the drop piece

were adopted. This drop piece slides in a flat tube built up out of similar sheet metal, a pair of circular holes corresponding to the maximum working aperture of the lens being cut in this flat tube, and the whole arrangement fits into a slot which must be cut through the lens tube just in front of the diaphragm guide; a pair of arc-like pieces of brass, which are soldered on to the apparatus, serving the double purpose of keeping out light, and of ensuring that the apparatus shall always be so placed that the circular apertures correspond with the central portions of the lens mount.

The arrangement for releasing the drop is neat, and well worthy of note. Figure 4 represents it in section. The three interior lines represent a sectional view of the flat tube and the drop, while the outer shaded portion stands for a light metal frame which can slide across the apparatus, but which is held towards the side A by the spiral spring. Under these circumstances the internal stud shown near B presses on the drop, and may support it either at the point C, figure 3 (half-cock),

or at D, figure 3 (full-cock). Pressure on the end A of the sliding framework serves to release the drop.

To use the shutter, a slot has to be cut through the tube of the lens close to the diaphragm; then the shutter is inserted in the opening, the small flange keeping it in place, and preventing light getting in. To focus, press the spring slightly, at same time drawing up the drop till it catches and leaves the shutter open. To expose, draw up the drop to its last catch. A very slight pressure on spring A releases the shutter, which falls and shuts itself; a small piece of lead on B prevents any jar when the drop falls. It is well to carry several drops with different sizes of openings, using them according to light, subject, &c.

It will be well for our readers to bear in mind that it is generally undesirable to cut the lens tube for such a shutter as that of Mr. Valentine, it being a much preferable course to send the lens to the maker and get him to make a special tube with the required slot in it. On one occasion we required such an extra tube for a lens by one of the leading opticians, and the extra tube was in our hands four hours after we had taken the lens back to the maker.

T & R Allan
at Glasgow

Messrs. Annan, of Sauchiehall Street, Glasgow, deserve honourable mention, if only for this: they are the one firm of photographers north of the Tweed which manufactures and uses its own carbon tissue. Many of us know the difficulties and vexations of carbon printing; but few have had the courage to make tissue for themselves, and fewer still continue to do so in spite of heart-breaking failure and systematic discouragement. Messrs. Annan Brothers have for years steadily clung to the production of carbon tissue, and, at their works at Lenzie, near Glasgow, have succeeded in producing a material of excellent quality, as abundantly proved by the transparencies and enlargements which issue from the firm.

At Lenzie, too, Messrs. Annan have a manufactory of gelatine plates; but, in the present paper, we shall confine ourselves simply to a description of the Glasgow establishment, which furnishes us with matter quite sufficient for our purpose. Here, in the Gallery at Sauchiehall Street, we perceive at once one very important fact, namely, that permanence in photographic prints is one of the principal aims of Messrs. Annan. Look at this carbon print upon opal, representing Sir Noel Paton's *Fairy Raid*. It is a photograph finished in black and white, we

are glad to hear, by the artist himself, a circum-
stance alone that deserves record, since it shows
that photography is no longer looked upon with
such jealous eyes by painters. This carbon print
upon opal measures no less than four feet, certainly
the largest and finest we have seen of the kind, while
we need scarcely speak of its excellence and beauty,
since it has been so highly appreciated by Sir Noel
Paton. Messrs. Annan have published many works
of art of this kind, and, as photographic publishers,
indeed, they take very high rank. Here is a series of
portraits of the professors of Glasgow University,
both taken and printed in carbon by Messrs. Annan,
than which no finer collection of its kind has ap-
peared. The portrait of Sir William Thompson, the
electrician, is one of the best of them (they are taken
8 1/2 by 6 1/2 inches), and it is something to reflect
that such good portraits are printed in permanent
pigments. Here is a volume containing the divin-
ity professors, and yet another filled with those
of the medical staff, all of them names famous
in the University world. In fact, Messrs. Annan
might well be termed photographic publishers to
the University, for we find still another volume
filled with views of the Old College, which dates
back to 1450 – photographs that must be dear to

all those inhabiting the second city of the empire, as we believe Glasgow is now entitled to rank.

Another excellent series of pictures we must allude to before we pass from this subject. They depict the whole of the painted windows in Glasgow Cathedral, and form a valuable record of this branch of the art. There is almost colour in some of those casements, so delicate are the halftones; while the "staining" effect upon the glass could scarcely be better in the original windows. There is not, strange to say, a single instance of halation or blurring in these window pictures, which represent masterpieces of the modern German school. They are the work of Hess, Schrandolph, and Moritz von Schwind, the last-named artist distinguished more especially by his being chosen to renovate the Castle of the Wartburg in Germany, revered by the whole Lutheran Church on account of Luther having translated a large portion of the Bible within the venerable pile. The art of modem window painting – so far, at any rate, as designs go – may well be studied from this fine series of photographs, which puts vividly before the student, sitting at home at ease, transcripts of the master's work. Indeed, in glancing over these valuable publications of Messrs. Annan, the idea

comes over us now and again, whether such work is sufficiently recognized. At Messrs. Braun's establishment in Dornach, which we visited a dozen years ago, a great deal of work of a similarly classic character is also prepared, and we could not help calling to mind the Alsace studio as we examined Messrs Annan's photographs. Fortunately, as in the Dornach establishment, these reproductions are all in carbon, and hence we may trust that the work undertaken at such great expense may, by reason both of its intrinsic value and permanence, be ultimately a source of profit to its progenitors.

As landscape photographers Messrs. Annan enjoy an enviable reputation. In London, we have repeatedly been made familiar with good work from the Glasgow studio; but, to thoroughly appreciate its skill and taste, it is necessary to examine the beautiful pictures of exteriors and interiors of Scotch strongholds which here adorn the walls. Here is princely Glamis Castle, with its rounded turrets and spires, its grey walls, its weather-beaten casements, and handsomely wrought stonework. Here is Alnwick Castle, its fine lines sharp and clear in the leafy landscape; here Dumbarton Castle on the Clyde, and here again Hamilton Palace. But better than all are

these interiors taken on 16 by 13 plates, some by a Dallmeyer 12 by 10 rectilinear, and others by a Ross wide-angle lens. The *Duchess' Bedroom*, for example, is perfect; the satin bed furniture, the quilted coverlid, the folds in the rich drapery, are rendered as softly as by the painter's art, while yet they possess all the detail and clearness of photography. *The Library, Hamilton Palace* is not less successful; the furniture, the bookcases, the table-cloth – all are rendered with surpassing harmony and clearness, as if, forsooth, the photographer had chosen accessories of his own shade and hue, in order to secure the highest effect. There is no blurring, no halation, no solarization; the light is diffused as evenly and effectively as in a well-lit studio. All these interiors were taken with wet collodion, some of them with nearly an hour's exposure. Says Mr. Thomas Annan: "I use gelatine plates of our own making for interiors now, but we have not given up the use of collodion for outside work."

We go upstairs. Here are carbon prints and carbon transparencies in various stages. Impressions measuring 24 by 18 inches are considered but ordinary work, and three-feet pictures are not made much fuss about. The enlarging is done in the usual way from a carbon transparency, produced by

printing upon tissue under the original negative, and in this way securing a vigorous, transparent positive. Some of the red-tissue prints of Messrs. Annan are very successful. A huntsman surrounded by his pack on the steps of a hunting-box looks like an old engraving by Hogarth, and so anti-photographic is it in appearance, that one wants the assurance of the printer almost to believe it.

The studio is spacious and roomy. It is lighted from the north; but the sun itself never gets into it the whole livelong day. What there is of wall on the light side of the studio is painted dark, while the bare glass is, for the most part, obscured by curtains of very dark blue. On the shadow side of the studio the walls are of a light tint. One feature deserves special mention. The slope of the roof is but slight, and on both sides it is glazed; but, on the shadow side, the glass is covered in by seven or eight boards, their ends towards the apex of the roof. Under ordinary circumstances, therefore, they permit no top side-light to enter from the shadow side. At times – in winter more especially – light is, however, desirable from this particular direction. For this reason the planks are hinged lengthways, and capable, therefore, of falling or assuming any slope – and, therefore,

casting more or less light – towards the object to be photographed. Two cords – one near each end of the plank or board – permit of moving the plank, and either allowing it to fall altogether, so that it hangs edgeways, or of pulling up the flap flat with the roof, in which circumstance no light at all enters.

The darkroom is one of the best ventilated we have seen. There are two ventilating shafts, one on each side of the apartment, with pipes no less than eighteen inches in diameter. The shafts are not only bent at an angle, like a magic-lantern chimney, to keep out rays of light, but there is, moreover, placed at a short distance below the orifice of each, a dead-black disc, to make security more secure.

STUDIOS IN FRANCE

not only because it is one of the last and
of a gifted artist, but because it shows h
upon the shoulders of Adam-Salomon.
he held high rank as a sculptor ; but, ski
use of the chisel, it was as a photographei
to the four corners of the earth. Stran
begin photography till 1861—it was one
said to us—and yet, in 1867, at the Pari
him so far ahead of all other portraitists
undisputed by his own countrymen, and
edged in every land.

But to return to our visit. M. Adam
the gravel walk to unlock the gate for us
and more flowing than it used to be a doz
irst met the *premier* portraitist, but he i
winsome as ever. In his button-hole he
ibbon of the Legion, and his manner has
t. He calls out a blithe welcome as he
gate, and shakes hands again and again.

In his kindly hospitable fashion he ha
léjeûner with him ; but come early, he h
'ous chasse." So between ten and ele
norning, we present ourselves at the litt
green confines of Paris and the fortifica
unsafe to inhabit during the investment
Germans in 1870. The balmy air is redo
vallflowers, and it is so warm that the l
pen. As everybody knows, M. Saloman
s a photographer, and evidence of his ha

Adam-Salomon
in the Rue de la Faisanderie, Paris

M. Adam-Salomon died the week after Easter last year, and it was on Easter Sunday and Easter Monday that we last had the pleasure of meeting him. Although suffering from impaired eyesight, he was then in good health and spirits, and talked hopefully of an operation for cataract which was to bring back to him his strong vision once more. On Sunday, a hot summer's day, he was in company with an old colleague, a doctor of medicine, and brother Chevalier of the Legion of Honour, and during a stroll together in the sunny garden among the odorous wallflowers and fresh green chestnuts, there was a running fire of gaiety and jokes. They called blithely to one another among the trees, and rallied each other like schoolboys. "Where are you, *docteur*?" cried M. Salomon, lustily, for the doctor had seated himself in an arbour, out of pretence to avoid the artist's raillery. "Where you can't find me," was the other grey-beard's reply. With all the freshness of a lad of twelve, M. Salomon quizzed his friend about his cleverness, whereupon "*docteur*" replied that his hair had not grown white for nothing. "Cheveux blancs," cried M. Salomon, explaining to us what an impostor his friend was; "il est un brun, avec la tête poivrée."

We like to recall the scene now the kindly

heart beats no more, not only because it is one of the last and brightest reminiscences of a gifted artist, but because it shows how lightly his years sat upon the shoulders of Adam-Salomon. Everybody knows that he held high rank as a sculptor; but, skilled as he was in the use of the chisel, it was as a photographer that his fame travelled to the four corners of the earth. Strange to say, he did not begin photography till 1861 – it was one of the last things, he said to us – and yet, in 1867, at the Paris Exhibition, we find him so far ahead of all other portraitists, that his position was undisputed by his own countrymen, and spontaneously acknowledged in every land.

But to return to our visit. M. Adam-Salomon comes down the gravel walk to unlock the gate for us. His beard is whiter and more flowing than it used to be a dozen years ago, when we first met the *premier* portraitist, but he is as genial, as warm, as winsome as ever. In his button-hole he jauntily wears the red ribbon of the Legion, and his manner has all the old gaiety about it. He calls out a blithe welcome as he rattles the key in the gate, and shakes hands again and again.

In his kindly hospitable fashion he has insisted on our taking déjeûner with him; but come early,

he has said, for "à midi je vous chasse." So between ten and eleven, this sunny April morning, we present ourselves at the little villa, so close to the green confines of Paris and the fortifications as to have been unsafe to inhabit during the investment of the capital by the Germans in 1870. The balmy air is redolent with the odour of wallflowers, and it is so warm that the house door stands wide open. As everybody knows, M. Salomon is a sculptor before he is a photographer, and evidence of his handiwork is here in the little garden, and in the handsome gallery we now enter.

A pleasant chat about friends and acquaintances who have visited him in Paris, or M. Salomon has met in London, revives recollections of that famous display of portraits in 1867, when he took the photographic world by storm. The long article by the *Times* special correspondent at the Paris Exhibition, in which a high tribute was paid to M. Salomon's pictures, our host still remembers with unaffected delight, as also the many other recognitions of his work that have come from Great Britain. His skill as a sculptor has been no less complete, and M. Salomon speaks with deep feeling of the homage paid to his work by the English press, particularly in respect to the

bast of Mr. Chadwick, C.B., exhibited two years ago at the Royal Academy. Unfortunately – and our readers will read it with infinite regret M. Salomon's eyesight for some time past has been very defective and has compelled him to put aside almost entirely his photographic work. "Here is my last essay at posing, "said our host, showing an unmounted print; "I did it the other day, but I was able to do no more than pose." It is a standing portrait of a violinist at the moment of *attaque*. The chin presses the instrument, the arm is raised, the bow just touches the strings – the musician will instantly commence.

"It is a gelatine plate, of course, with a pose of three seconds," says our host: "I could not have secured that with collodion."

An exposure of twenty seconds he used to consider a short one in taking the brilliant 10 by 8 pictures for which he was so famous – pictures, as our readers know, not less delicate than they were brilliant. A portrait of Mr. Blanchard, which he took in Mr. Blanchard's own studio in London, is here, and M. Salomon shows it us with pardonable pride, for it proves how well he can succeed far away from his own studio and familiar surroundings.

On either side of the spacious gallery

– furnished with rich Turkey carpet and hand-some Louis XIV furniture, its walls being deep chocolate – are examples of his skill as a sculptor. A bust of the late Pope Pius IX is here, to model which, a journey to Rome was necessary. This is Guizot, full of force and vigour; and this Cousin, another noted French minister, a magnificent work in white marble. Earl and Lady Granville are to sit to our host as soon as his eyes are better, he tells us; at present he is engaged in modelling a bust of Thiers, which we are forthwith invited to see in the atelier. We pass into the garden, and thence into a large room where finished and unfinished work is on every hand. M. Salomon throws off a cloth, and before us, in dark plastic clay, are the familiar features of the late liberator of his country; the lips seem to speak, so full are they of life and vitality, and one can almost perceive a smile playing over the face of the benevolent statesman. It is a marvel-lous work. These grand models seem to point to the reason of our host's success in photography, for his portraits are essentially statuesque. Belief and plasticity is a marked, if not the principal feature in them, and when we are further invited up into the photographic studio, we see unmistak-able signs of M. Salomon's great endeavour to

give a statuesque character to his work. Repeated accounts have in past years appeared of M. Adam-Salomon's method of working, but, for all that, our readers will forgive any repetition, we are sure.

The studio is on the first floor of a detached building in the garden, so that light from every side is available. "A droite, à droite, je vous prie!" cries M. Salomon, as we mount the wooden steps, for they are a little unsafe in places. The studio is very spacious, and very few curtains are made use of; so roomy is it, indeed, that you might point the camera in any direction. The principal light is top-light, and here is the alcove or semi-circular

background which M. Salomon has repeatedly used with such effect. It is some twelve feet across, and, inside, of a chocolate colour. The way to use it is very simple, and it has the advantage of producing almost every effect of lighting. If need be, the model need not move at all. He stands or sits in the centre, and the semi-circular background is revolved, if we may so call it – shifted round a little to one side or the other –as the photographer deems necessary. Thus the lighted side of the model may be contrasted with the shadow side of the background, and *vice versa*. Again, the background may be bodily advanced or receded from the light – the model remaining stationary – when another modification of the illumination is brought about. Many photographers have a bust or statue in the studio as a *corpus vile* whereon to make experiments in lighting, &c. M. Adam-Salomon, although himself a sculptor, with an array of these at his disposal, does not avail himself of such aid; he employs something more to the purpose. "Madame Tussaud's," he says, jokingly, as he pulls aside the curtain from an alcove. We see two life-sized figures dressed in black coats and trousers, and, to all appearance, *habitués* of the famous Baker Street establishment. These models

M. Salomon employs for his essays in lighting, and since he has here the contrast of black drapery and white features, which is the plague of the photographer, he knows pretty well that if he can succeed with these, he can succeed with live models.

M. Salomon is an indefatigable experimentalist; for some time he employed a red-glass camera in his work – this is, a camera with windows of red glass on top and sides – and he has still a good word to say for it. It was quicker in action than the ordinary camera, and in some circumstances, the slight greyness in the prints from negatives taken therein was not disadvantageous; but, of course, with gelatine plates any accelerating means of this kind are quite unnecessary.

All who have seen M. Salomon's pictures know that these were never issued unmounted. In the same way as no effort was spared to secure in the highest degree results of modelling and harmony, so M. Salomon never neglected the smallest detail in finishing and mounting his pictures, with the view of securing the very best ensemble. His portraits were not only mounted upon glass, but rubbed with a wax or paste, the composition of which has already appeared in these columns, and which we repeat at the end of this article. No better

"finish" has since been suggested, and Salomon's encaustic paste still finds a ready sale on the Continent and in this country. M. Salomon told us he had himself purchased it at various times, and laughingly alluded to the grave protestations of a shopman to whom, on one occasion, he had expressed doubts as to the efficacy of the compound.

"When in London I purchased, too, some pictures of myself," said M. Salomon, recounting another anecdote. It was "*dans la cité*" and naturally he desired, before making the purchase to know whether the portrait was *ressemblant*. "Très ressemblant," was the shopkeeper's assurance; "and on the strength of his word," continued M. Salomon, "I purchased half-a-dozen of the pictures. But from that day to this I could never trace the resemblance myself."

Here is the composition of the Salomon paste, and manner of employing it:

Pure virgin wax 500 parts
Gum elemi 10 parts
Benzole.................................. 200 parts
Essence of lavender................. 300 parts
Oil of spike 15 parts

Melt the whole on a water-bath, mixing

thoroughly, and strain through muslin. Or the elemi may be dissolved in the solvents and the melted wax added after filtration. To make it thinner add a little more lavender essence.

The encaustic paste is put on the print in patches in three or four parts, and then rubbed with a light, quick motion, with a piece of clean flannel. If a thick, rich coating be desired, a very light pressure in rubbing is used. In the case of a retouched print, the rubbing should be very light.

M. Nadar
in the Rue d'Anjou St Honoré

In the dark days of the Paris siege in 1870-71, when the fair capital was encircled for nearly six months as by a girdle of iron, two photographers brought hope and comfort to the besieged citizens. The one (M. Dagron) showed with what rapidity and facility despatches were to be photographed upon pellicle, and in such a way that a pigeon could carry a thousand of them at its tail; and the other (M. Nadar) as captain of a balloon equipment, demonstrated how aerial photography could be practically applied for scouting. "A la nouvelle de l'approche de l'armée Prussiene," we read, "sous les murs de Paris, M, Nadar organisa à Montmatre le premier poste de ballon captif pour observer l'ennemi."

In the words of our neighbours, MM. Dagron and Nadar deserved well of their country, and although their brother citizens would wish to forget as speedily as possible those anxious hours of misery and bloodshed brought so vividly home to them, they still remember with gratitude the aid which these gentlemen brought at a time of dire distress. It is an ill-wind that blows no good, and among other lessons that the siege of Paris taught was that a regular *poste aérienne* could be established nowadays by the aid of photography and balloons, and that the latter,

moreover, afforded an excellent means of observation or reconnoitring for an army in the field.

Our host, the captain of the aerial scouts, in the red blouse in which his stalwart figure is usually attired "at home", presents a handsome figure enough; M. Nadar is still in the prime of life, his fair brown moustache and bright eyes conveying the idea of strength and determination, while his broad shoulders tell that he can both do and dare. His aerial photography experiments, he tells us, have cost him 30,000 francs; he considers the problem, however, practically solved, and if his balloon pictures are not perfect in every respect, they require but little more attention to detail to render them so. But one fine example, we may say at once, leaves little to be desired. It is a picture to which the late Sir Charles Wheatstone referred us on one occasion, during a discussion upon aerial photography, as the best result of its kind. Balloon photographs are very rare, and, besides those of Nadar, we only know of one tolerable success, namely, a picture of Boston, U.S. The pictures of M. Nadar were secured upon three-inch plates with the briefest of exposure, and have been enlarged to something like twenty inches. The most successful of all, of which we have spoken, was secured at

a height of 320 metres. There is, of course, something of a haze, due to the flood of light; but we see the main buildings of Paris and the heights around with map-like distinctness. To the extreme right, is just a corner of the Arc de Triomphe; there are the Eglise Russe and the Pare Monceaux, with twenty spires and domes that a Parisian would recognize and call by name. Great difficulty was experienced in overcoming the gyrations of the balloon; but, after all, it is rapidity of exposure, according to M. Nadar, that is the key of the problem.

The Nadar establishment is a very extensive one. Passing through the corridor you enter a fine square hall, which probably measures forty feet each way. Here are pictures of Paris, under the earth and over the earth, the former, representations of the famous catacombs, secured by electric light. M. Nadar, junior, was good enough to accompany us on a tour of inspection, and chatted affably over prospects of photographers and their position. The *carte panneau* – the panel portrait – was already in such requisition at the Nadar establishment that quite one-third of the work done was in this form. Besides this new format, there was the *carte Nadar*, a very large and handsome format, about the size of two panel portraits

placed side by side. The price charged for panel portraits was 120 francs the dozen, while as much as 200 francs per dozen was asked for the carte Nadar. Thirty francs, for which the sitter received fifteen cartes-de-visite, was the lowest fee charged.

To ascend from the magnificent entrance hall a lift is provided, which takes the visitor to the dressing-rooms and studio. The former are tastefully fitted up, and the studio is large and lofty. So lofty, indeed, and so much light is there, that blue curtains are stretched across at some distance from the roof to lessen the illumination. These blue linen curtains are strung on wires, so as to be manipulated with ease. There is very little skirting-board or wainscoting, the side window coming down very low. They like dark backgrounds at the Nadar establishment (those we saw were all of a blackish drab), and, to prevent the flooring being seen in a standing portrait, or the line of the background where it touches the floor, sand is thickly strewn about. The effect of the latter was remarkably good in the panel portraits we saw.

M. Nadar *fils* discussed with us at some length the difficulty of securing talented assistants. It is not a question of money at all, he assured us; good competent photographers, who are artists as well,

could command high prices. The pay of assistants *du premier rang* was 600 francs per month (£240 per annum); but he knew a case – an isolated one, it is true – in which *mille francs*, or double the above amount, was paid. In the principal studios in Paris, Vienna, and Berlin there were assistants of all nationalities. But while the Germans, some time ago, by reason of their skill with the retouching pencil, were to the fore, the Italians now seemed to be making way. These rates, of course, only referred to first-class men; but they were such as well-known studios paid. Unfortunately, the number of talented assistants available was very small, for he who secured a good man took care never to lose him again. A percentage of the profits, or sometimes an offer of partnership, was necessary to retain him. The studios of Vienna, Paris, London, Berlin, &c., in the first rank were, after all, not very numerous, and consequently you might tell the number of competent assistants upon your fingers.

As to photographic apparatus, said M. Nadar *fils*, touching upon another point, you have it all your own way in England. "I am coming to London in a little while, and for no other reason than to purchase instruments and apparatus," "But don't you find our apparatus rather more

expensive than what you buy on the Continent?" we naturally asked. M. Nadar did not think so. "Your work is so good that it always pays to buy it." So our opticians and camera-makers need not despair yet, and we hope sincerely that they may long continue to enjoy the same reputation. That they have been in the van for years past is well known. Ten years ago, when on a visit to Dr. Vogel, in Berlin, we well remember the ecstatic delight with which one of the worthy doctor's pupils spoke about the new camera that was coming all the way from England. We often think of him now, when we see the shining mahogany, and its brass and ivory fittings, and wonder if our sanguine friend in Germany was satisfied with the apparatus which gave him so much anticipatory pleasure.

The Nadar establishment is singular for the fact that no cartes *émaillées* issue from the premises, a style, as we have before remarked, which is still exceedingly popular in Paris. For the glaze and embossing, the public are quite willing to pay half as much again, and thus both customer and photographer join hands. But M. Nadar is evidently bent upon pushing the panel picture instead, and, as the portraits of a large number of celebrities have recently been published in this form, it is daily

growing more and more popular. At the same time, 120 francs is not an amount that all the world and his wife is ready to pay; although it always seems to us that a sum that visitors grudgingly give at home is freely disbursed in the French capital.

Those who visit the Rue d'Anjou will say that M. Nadar has given up the command of his war balloons to some purpose. He seems to be quite as successful in his peaceful pursuits here, as when scouting in the air with the Prussians, at the walls of Paris – as good a man behind the camera as before the enemy.

The Préfecture de Police in Paris

A stone gateway, with a red flag drooping over it, is pointed out to us as the Préfecture. The armed sentry in front asks no questions, so we pass on under the arch into a cheerful courtyard smoothly asphalted. We bear a long, official-looking document by way of introduction, and this we keep ready to hand, lest some sudden attempt at arrest be made, before there is time to show our credentials. Fortunately there is no fear of this. A policeman in the courtyard bars the way for the first time; but he is anything but a dangerous character. He is disposed to be argumentative, though, and in the end gets very excited over the address on the letter. It is for the chief of the Paris detective department, but, unfortunately, the name has been written with a *y* instead of an *e*. We point out that probably this will make no difference – it is the same thing. "But it is not the same thing," is the hot reply. "'Cet y grec là – what does it mean?" As he taps at the *y grec* excitedly, we carefully look at it again, but can afford no other explanation. "Dites donc, M'elle," says the policeman, turning to a young lady who is quietly sewing at an open window in the courtyard; "have the goodness to look at that letter." The young lady reads the address, and thinks it is all right. "Mais cet y grec," responds

the guardian of the law, still warmly. The young lady calmly thinks with us that it does not matter much, and in these circumstances the policeman gives the point up, and permits us to proceed.

Upstairs to the top of a lofty building and we enter an anteroom, where several stern-faced men, clothed from top to toe in sombre black, are sitting at a table. We perform our best bow, and present our credentials. No one makes an observation, but we are carefully scanned, and then ushered into a salon, and the handle turned upon us.

It is a salon comfortably furnished, the chairs and settees uniformly covered in dull, green cloth. There are no nick-nacks beyond a clock, which ticks solemnly. The walls are bare; the sideboard is bare; but on the table are two solitary objects, an inkstand and a little bowl of sand, for the instant drying up of writing, so that you could be sent to the Bastille – if there were one – on the spot. Time goes on, and we wait a good half hour by the clock in the salon vert. We begin to wish we had read that letter of introduction before we presented it. "Lock up the bearer," or "The gentleman being rather inquisitive, keep him for the morning and let him go," might have been inside. We have plenty of time to think over the

insanity of practical jokes, and the silliness of some people who continually practise them.

Presently the door is opened, and one of the solemn black greffiers beckons us. Without a word we follow him down one passage and up another, until he throws open a door, and we are in the presence of the chief of the Paris detective police.

A courteous gentleman, still young, with a smiling face and friendly manner, we find him, this head of the secret machinery of the gay capital; he is good enough to place himself entirely at our disposal. "I will accompany you through our photographic establishment myself, and you shall see everything that interests you."

He is as good as his word. He puts on his hat, and leaving word with one of our former solemn gaolers that he is gone to the photographic establishment, accompanies us down several flights of steps. We cross a yard, and perceive through an open door the dark forms of policemen, ready armed and accoutred, lying at full length over the floor in various attitudes. "La poste," explains our friend – it is a force ready to turn out for duty at any moment. We reach at length the basement of the building. Here all is prepared for our reception; we had evidently been kept waiting until the

rooms were put into apple-pie order. An officer of the rank of inspector of police, under whose direct charge the rooms are placed, receives us, and in his company we proceed to make the inspection.

This is the mounting and finishing room, and here are batches of prints – carte size – ready for issue. Let us look at this double row of portraits on the table, first of all; they are copies, and taken obviously from portraits more or less good. They are of men, some of them old, and some very young, habited in ordinary dress, and for the most part very untidy about the hair and beard. There is not the trace of a razor among them. Hairy individuals, who have an aversion to the barber, and whose features would evidently be improved by the lavish application of yellow soap, they are most of them the counterparts of whom may be seen every day in the back streets of Soho. "Nihilists," the chief briefly explains.

Affairs in Russia have made European Governments extra cautious about the unsoaped and unshaven of the community; and this collection is the result of extensive research by the police of Paris.

"Enfants perdus," explains our friend a second time, for we have taken up some pictures of children who seem innocent enough. These portraits

are exceedingly useful in trying to find out parents; the police carry the pictures into any quarter in which the children are likely to be known, and show them about. Photography has been found a most efficient aid in restoring children to their parents, or rather in discovering the whereabouts of those who have deserted their offspring.

These pictures are scarcely so attractive. The dull look of remorse borne by most of their sad, still faces is terrible; they are portraits taken at the Morgue, where all unknown dead bodies found in Paris are carried. A large number of copies are printed if foul play is presaged, but every unknown body is thus recorded.

This heap of untrimmed and unmounted portraits of men and women represent the daily takings of the Paris police. They will be mounted, sorted, and presently put upstairs in the Record Office. They are ordinary persons enough, the sitters, of a low class most of them, but with nothing at all to show they are criminals. As portraits they are admirable, however, and we may at once say that the work at the Préfecture is simply very good indeed. The manner of proceeding by the Paris police is as follows: Everyone charged with crime or misdemeanour of a grave nature, who

is brought to the Préfecture, is photographed forthwith. It does not matter whether in the end he is proved innocent or guilty, he is taken to the studio, which is situated in the same block of buildings as the court. As the prisoner quits the court he is at once brought before the camera. On an average, forty to fifty portraits a day are taken, and these are forthwith printed; some few may afterwards be cancelled, where innocence is manifest; but if there is the least suspicion, the portrait is pigeon-holed; it maybe difficult to take the likeness a second time. In this country, as most of our readers know, it is not permitted to photograph an unconvicted person. Gelatine, by the way, has not yet found its way to the Préfecture; as the portraits are only carte size, however, an exposure of five or six seconds usually suffices.

The French criminal portraits are certainly more valuable than our own. The men and women in Paris are portrayed as they usually are in everyday attire, and with all their peculiar personalities about them, as to manner of wearing hair, beard, &c. Most of our portraits, on the other hand, depict the men shaven and shorn, in the grey convict dress, and therefore as they are never likely to be seen outside the prison walls. In France the

governors of prisons care little about the appearance of their charges; it rests with the detective and police department to look after criminals at large, and these authorities, to assist themselves, prefer to have portraits of the men and women as the latter are seen everyday in the streets.

We go upstairs into the Record Office. There are two huge presses, containing in all the portraits of 40,000 bad characters. In one press are portraits arranged according to names, in the other according to crimes. In deep pigeon-holes fit long narrow trays, full of cartes-de-visite. Each tray measures about two feet in length, and when slipped into the pigeon-hole, it shows on its outward face certain letters of the alphabet. The first is marked A-AM, and it contains portraits of criminals whose names begin with these initials. The cartes are loose in the long box, but all in order, so that a man or woman may be picked out at once. Here, in the other press, the pigeon-holes are divided into groups, over each being the nature of crime, such as *assasinat*, *vol*, *expulsés*, *moeurs*, &c. The chief, at random, takes down a long box of the *expulsés* or banished ones, and looks them through. "We divine what he is doing. Out of compliment to ourselves he is trying to find an Englishman among them, but his

search is in vain. Italians turn up without number, and Austrians and Russians, but no English. We suggest that the search is impossible – there are no bad Englishmen. "Attendez," says the inspector, and he goes to work at another box. But *chef* and *sous-chef* are equally unfortunate, and in a few minutes laughingly give up the job. The name and other particulars are scratched on the negative, so that they print in black upon the portrait, and are quite inseparable. This is a neater and better plan, we think, than chalking the particulars on a blackboard and photographing the latter with the convict, the plan adopted in Great Britain.

Another feature in the photographic establishment is the enlarging of handwriting, to establish, if possible, identity of character between an acknowledged hand and that upon a spurious document. Here is a name written across a receipt-stamp enlarged ten or twelve times; there is no difficulty about examining the giant up and down strokes in every particular. If any writing is characteristic of a man, the character comes out in a marked manner as soon as enlargement takes place. Any slight spluttering of the pen in making an upstroke, or any particular flourish or defect about certain letters, is at once detected. On the

walls of the Record Office are many examples of en-larged handwriting, which have served to discover forgery, and of which the police-photographers are very proud; they attach, indeed, exceeding impor-tance to this feature of photographic detection.

The printing room and the washing room offer little of importance; they are well arranged, exceed-ingly clean, and judiciously appointed. But before taking our departure, the chief invites our attention to the photographic carriage, which is a valuable item of the establishment. It is a fine vehicle, painted black within and without, about the size of an ordinary police van. It is fitted as a dark laboratory, with sinks, shelves, handy seats, and all conveniences. In cases of fire, murder, and serious crimes, a view is taken of the scene or surroundings, and if a body is found under suspicious circumstances, a photograph is taken on the spot, if possible, before the body is tampered with. It is to perform duties of this descrip-tion that the van is made use of; and such importance does the Préfecture attach to photographs secured on the spot, that it did not hesitate to spend a sum of 7,000 francs on the vehicle. On the whole, the police photographic establishment in Paris is most com-plete; and it is not only a model establishment, but one that has not its counterpart in any other country.

Index

Also from MuseumsEtc

Naturalistic Photography

By P H Emerson

ISBN: 978-1-907697-58-6 [paperback]
ISBN: 978-1-907697-59-3 [hardback]

Order online
from www.museumsetc.com

P H Emerson's *Naturalistic Photography* is one of the classics of photographic literature.

This newly designed and typeset edition takes the text from the definitive 1899 edition and includes three additional essays by Emerson, among them the controversial *Photography - Not Art*.

Compared at the time to "dropping a bombshell at a tea party", *Naturalistic Photography* was the start of a crusade against the academism of artistic photography.

Dubbed "the Martin Luther of photography" (John Szarkowski), and more recently the "one of the most virulent polemicists in the history of photography" (Thomas Galifot, Musée d'Orsay), Emerson's fierce and trenchant writing is in sharp contrast to the gentle, atmospheric images of his pioneering photobooks *Life and Landscapes of the Norfolk Broads* and *Marsh Leaves*.

Emerson's texts are today recognised as ranking alongside those of John Berger, Roland Barthes and John Szarkowski, as the precursors to contemporary thinking on photography.

Photography and the Artist's Book

Edited by Theresa Wilkie,
Jonathan Carson and Rosie Miller

ISBN: 978-1-907697-50-0 [paperback]
ISBN: 978-1-907697-51-7 [hardback]

Order online
from www.museumsetc.com

There is a renewed interest in the relationship of photography and the artist's book, both as a work of art and as an alternative means of exhibition and dissemination.

There is also a notable expansion in the activities of self-publication by photographers and artists who use the photograph.

Furthermore, the theorising of the photographic essay, and notions of "conceptual documentary", have become important areas of discourse for practitioners and theorists alike who are interested in working with the photograph in book form.

This important new publication provides a broad international perspective, bringing together writers from Australia, Germany, Ireland, the UK and the USA - both leading theorists and leading practitioners - to more fully explore the issues raised by the relationship of photography with the artist's book.

VERTICALS | writings on photography

History and Handbook of Photography
Gaston Tissandier (trans. John Thompson)

Naturalistic Photography
P H Emerson

Photographic Studios of Europe
H Baden Pritchard

Photography and the Artist's Book
Theresa Wilkie, Jonathan Carson & Rosie Miller (editors)

The Photograph and the Album
Jonathan Carson, Rosie Miller & Theresa Wilkie (editors)

The Photograph and the Collection
Graeme Farnell (editor)

The Reflexive Photographer
Rosie Miller, Theresa Wilkie & Jonathan Carson (editors)

Order online at: www.museumsetc.com

MuseumsEtc Books

Academic Museums: Exhibitions and Education
Academic Museums: Beyond Exhibitions and Education
Alive To Change: Successful Museum Retailing
Contemporary Collecting: Theory and Practice
Conversations with Visitors: Social Media and Museums
Creating Bonds: Successful Museum Marketing
Creativity and Technology: Social Media, Mobiles and Museums
Inspiring Action: Museums and Social Change
Interpretive Master Planning: Philosophy, Theory and Practice
Interpretive Master Planning: Strategies for the New Millennium
Interpretive Planning Handbook
Museum Retailing: A Handbook of Strategies for Success
Museums and the Disposals Debate
Museums At Play: Games, Interaction and Learning
Narratives of Community: Museums and Ethnicity
New Thinking: Rules for the (R)evolution of Museums
Reimagining Museums: Practice in the Arabian Peninsula
Restaurants, Catering and Facility Rentals: Maximizing Earned Income
Rethinking Learning: Museums and Young People
Science Exhibitions: Communication and Evaluation
Science Exhibitions: Curation and Design
Social Design in Museums: The Psychology of Visitor Studies (2 volumes)
Sustainable Museums: Strategies for the 21st Century
The Exemplary Museum: Art and Academia
The Innovative Museum: It's Up To You...
The New Museum Community: Audiences, Challenges, Benefits
The Power of the Object: Museums and World War II
Twitter for Museums: Strategies and Tactics for Success
Wonderful Things: Learning with Museum Objects

Order online at: www.museumsetc.com

MuseumsEtc Videos

Cocktails and Culture: Cultivating Generation Next
Museums | Inclusion | Engagement
Planning and Designing for Children and Families
Real-World Twitter in Action

Order online at: www.museumsetc.com

Colophon